The Pursuit of Art

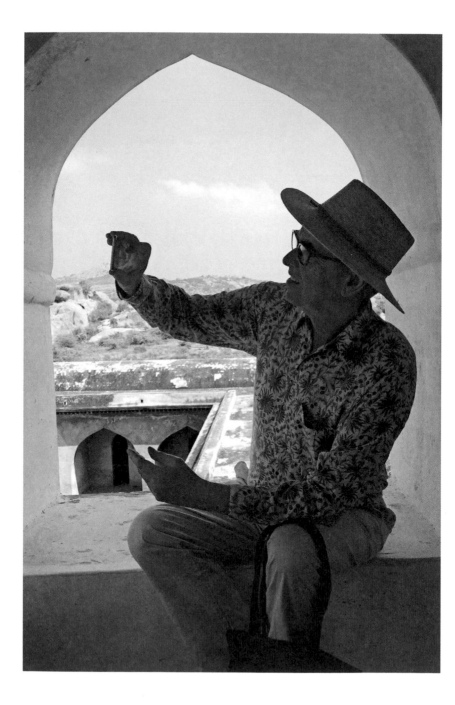

The Pursuit of Art

Travels, Encounters and Revelations

MARTIN GAYFORD

54 illustrations

Thames & Hudson

To Josephine, my companion on so many journeys

FRONTISPIECE Martin Gayford in Tamil Nadu, India, 2018

The Pursuit of Art © 2019 Thames & Hudson Ltd, London
Text © 2019 Martin Gayford

Designed by Anna Perotti @ ByTheSkyDesign

First published in 2019 in the United States of America by
Thames & Hudson Inc., 500 Fifth Avenue, New York, New York 10110

www.thamesandhudsonusa.com

Library of Congress Control Number 2019932284

ISBN 978-0-500-09411-2

Printed and bound in China by RR Donnelley

CONTENTS

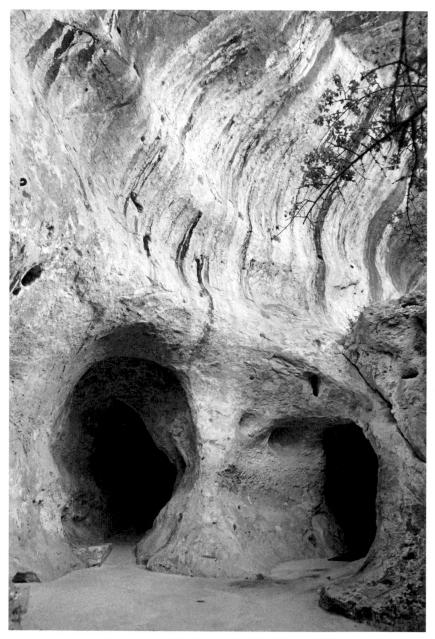

The entrance to the Font-de-Gaume cave, Dordogne

Introduction

The art critic Clement Greenberg once described what he did as carrying out his education in public. To an extent, that's true of most people who spend their lives writing, and certainly is of me. So one way of describing the events narrated in this book would be as episodes in my continuing education over the past twenty-five years or so.

To put it another way, it is about things that I've seen and people – artists – I've spoken to. In many of the excursions narrated in these pages the two go together. Visiting Anselm Kiefer's astonishing private studio-cum-museum in southern France, for example, went along with talking with him. Each intensified the other. Similarly, meeting Ellsworth Kelly face to face in the bright, clear light of New York helped illuminate his work. An artist's surroundings, their personal landscape, are often connected with what they do.

This remains revealing even when the artists themselves are no longer around to answer questions. I began to understand prehistoric art much better after I actually stepped into the caves of southwestern France. Classical Chinese landscape meant more after I looked at some original paintings in the Shanghai Museum, then stood in the swirling

mist on the peaks of the Yellow Mountain range. Of course, you almost always have to move around to see things properly. A great deal of the information embedded in a work of art is not – yet at least – accessible just by looking at an image of it while sitting at home. The deepest and richest experiences are not virtual but physical: they involve looking at real things and talking to real people.

Standing beside Brancusi's *Endless Column* gives you physical sensations of weight, mass and height that cannot be obtained in any way except by being there, beside it. To a greater or lesser extent, the same is true of all art: you have to be in its presence to feel its full effect – though some can transmit much more via a reproduction than others. You gather more about a small painting from a photograph than you do about a large sculpture.

There is a great deal to be said for the emerging practice of slow looking (begun, perhaps, on the analogy of the Italian Slow Cooking movement). We look, in fact, at variable speeds. Someone who is sufficiently attuned to a certain artist can tell in the blink of an eye whether a particular work is likely to be authentic or any good. But after that comes the slow looking, for hours, days – the rest of your life. And that is best done in front of the object.

It's not just that your experience is expanded in the presence of the real thing. You're different, too. As Roni Horn once explained to me, simply moving position changes you. Up to a point, that's always true: a corollary of the fact that we are organic and emotional beings with more senses than five, rather than simply a data-processing machine.

Many people have noticed that going for a walk is a way of getting your mental processes working. Just moving your legs starts ideas flowing. But going a great distance to see a work of art does more than that: it channels your attention in a certain direction.

The journey focuses your concentration. For a while, you think mainly about prehistoric art, Brancusi or whatever the destination is. As a result, you learn, and consequently alter a little – so you don't return exactly as you were when you departed. That, at any rate, is what happens if it goes well.

Of course, quite often it doesn't. There are plenty of potential tribulations, which is partly why I am a reluctant traveller as well as

a persistent one. There has scarcely been a departure on any of these trips before which I have not thought, Why, oh why, did I let myself in for all this trouble when I could have just stayed happily at home? I hate the moment of leaving. Nor do I like the tension of catching trains on time and getting to airports. I have a fear, not of flying – when airborne I feel my fate is in the hands of highly competent professionals – but of missing planes, which on a few occasions I have managed to do. For the mobile art lover, there are also the possible pitfalls of museums, churches and temples unexpectedly closed, and works absent for restoration or on loan to distant exhibitions (all of which I encountered in one day on my quest for works by Lorenzo Lotto).

Over a quarter of a century later, I still retain a visual image of the stretch of station platform at which I stared – with inner dismay – at the beginning of my long journey to Beijing in 1993. The fact that I still remember this is an index of the misgivings I must have felt.

In what follows, I have included not only the excitement of seeing something marvellous, but also the frustrations and discomforts involved in getting there. To omit these would be misleading – the pains of travel are part of the experience.

Just as you have to move to see something properly, the same is true in order to encounter new and intriguing people. Some of the journeys included in this volume felt like a proxy meeting with someone, such as Michelangelo, whom it is impossible to bump into in reality, but can be known – at least, I hope – from reading his words and experiencing his works. Many others recount real meetings: with Marina Abramović, Roni Horn, Henri Cartier-Bresson, Robert Rauschenberg and others. These involved journeys in space, but also another sort of movement.

Talking to such people is a privilege. Bill Clinton noted that the best thing about being President of the United States was that you could meet anyone you wanted. Luckily, I've been able to do that without having to go through the bother of election. Under the special terms of an interview many of the rules of ordinary social life no longer apply. You are allowed, within limits, to inquire about whatever you want, and the other person will reply. Indeed, often they positively *want* to talk about themselves and what they do. Under a certain impetus, such

as an exhibition about to open, even the most reticent characters may suddenly open up.

More than once during interviews I have found myself having conversations of startling ease and intimacy with total strangers, people whom I met perhaps on just one occasion. Sometimes, when I have met an interviewee again under more normal circumstances – at a dinner party, for example – I've noticed that this special licence has vanished and normal social rules once more apply. We have in effect to meet each other all over again.

An interview is a special sort of conversation, and good conversation involves an exchange of what you might call intellectual DNA. It requires, among other qualities, an ability to listen. When I was starting to talk to artists I was advised by David Sylvester, an older and much more experienced interviewer and critic. One point David made is that compulsive talkers make bad interviewers. The purpose of the exercise is not to sit down with some extraordinary person and tell them a lot of stuff you happen to think yourself.

You have to anticipate what may be said: mentally script the dialogue in advance. But you also need to be ready to shift direction, because it's the unexpected thoughts and ideas that tend to be the most revealing.

There's an example of that in my discussions with Jenny Holzer. These did not require anything strenuous in the way of travel: just a telephone call and a train trip to Oxfordshire. But her recollection about Leonardo da Vinci's *Lady with an Ermine* – as a child she assumed the lady *was* the painter – came out of the blue. It took me on an intellectual journey concerning, among other topics, the creative power of misunderstanding.

In 1947, the French art historian and politician André Malraux published an essay entitled 'Le Musée imaginaire', the imagined museum or, as it has been translated, 'museum without walls'. He argued that for a long time people made paintings, sculptures and artefacts without thinking of them as art. Then, a few hundred years ago in Europe, museums began to be established in which heterogeneous bits and pieces were gathered to be studied and admired for their aesthetic qualities. There were limits, however, to the kind of pillage this involved: extracting transportable items from temples and churches,

for example. No museum could be truly comprehensive or universal. Some things would remain too big or too rare for inclusion. There were limits also, Malraux thought, to the visual memories of even the most assiduous traveller. At this point, the revolutionary invention of photography came along and permitted everything from everywhere to be compared and contrasted.

That's all true, I think, but I would add that photographic images also have their limitations. So I find I am engaged in an attempt to experience everything directly – or as much as possible – despite the fact that this enterprise is everlasting and impossible. Indeed, those are attractions.

<p style="text-align:center">*</p>

One of the addictive aspects of travel is that it never seems to end. It is not only because there are always new places, works of art and artists to discover. If you find something, or somewhere, truly interesting, you can go back and back to it. That's because you are constantly changing and so is it – or at least that's how it seems.

Gillian Ayres, a painter from whom I learnt many things, once made this point to me. She was discussing the mutability of everything we see – and, I suppose, of everything else too. 'Every time you put a bloody picture up it looks different', Gillian exclaimed, with gusto. 'Every time the light is different, or you are different or something's different.'

Then she added an anecdote about one of her own journeys. 'I went to Chartres, and went back later in a different light and the place had changed – even the bloody building had.'

Gillian regarded this unending variation as a blessing. 'I love this! I accept it completely, and the way one can always relook and relook, it is one of the reasons one does. *Good!*' That's just how I feel too – and one more thing about art that I have discovered from talking to an artist.

BEING THERE

1 A Long Drive to Infinity: Brancusi's *Endless Column*

'Everything is slow in Romania', our driver Pavel said resignedly, and as it turned out he was not exaggerating. He was taking my wife, Josephine, and me on a trip of about 150 miles from Sibiu to see the sculptures by Constantin Brancusi at Târgu Jiu. There was, it was explained to us, a longer route, which might be quicker, and a shorter one that was likely to take more time. But neither, Pavel warned, would be exactly rapid.

And so it turned out. Going the faster way, we set off a little after 9 a.m. and arrived at about 2 p.m., stiffer, wearier and more comprehending of the reasons why so few people ever actually visit this fabled masterpiece of modernism.

Our mad excursion was propelled by my urge to see certain works of art for real. Over the years this impulse had taken us on quite a few Quixotic expeditions. There had been an interminable journey to the very toe of Italy, for example, undertaken to stand in front of the Riace warriors in Reggio Calabria. There are, many would agree, no finer works of ancient Greek sculpture in existence. But, as Josephine mentioned at the time, not everybody would spend days going to a town that was hundreds of miles from any other place we wanted to be, with

little else to recommend it, simply to admire two bronze statues of
rather aggressive-looking naked men.

In comparison, our current jaunt seemed no more than a detour.
We were already on holiday in Sibiu, a beautiful old town full of
Ruritanian charm. Brancusi's masterpieces did not look all that far
away, at least according to the map. This opportunity to view the
Endless Column in particular seemed too good to miss, partly because
it had the lure of the rare and inaccessible. Although this is among the
most celebrated works of 20th-century art, almost nobody – in the
London art world at least – has actually seen it. My inquiries suggested
that an intrepid Tate curator had made it there once, but that was over
a decade ago.

Maps, however, can be deceptive. As we eventually realized, nobody
in their right mind would make the excursion we were making, which
involved navigating a mountain pass through the Carpathians on a
road partly collapsed into a river torrent. Ideally, anyone wanting to go
to Târgu Jiu should start from somewhere else. But nowhere is all that
close. The Romanian capital Bucharest is five hours' drive away, in a
different direction.

Furthermore, I was misled into false confidence by the fast pro-
gress we made right at the start. In the morning sunlight, we sped west
from Sibiu down a motorway. This, however, turned out to be the one
stretch of good road we encountered all day, and it was quite short.
While we were on it, speeding along, Pavel asked if would like to stop
at the castle of Deva to admire the view.

This seemed an excellent suggestion, especially as we were making
such good time. So we did that, and then I made a mistake. Seeing that
we were almost going to drive right past Corvin Castle at Hunedoara,
I proposed we should pause briefly and look at that too. Josephine was
doubtful, and when he heard of this new diversion, Pavel – a large,
relaxed and normally equable young man – instantly became gloomy.
Then he turned into a maze of backstreets, abundantly supplied with
traffic lights, level crossings and other impediments. Finally, we
stopped outside a spectacular, though heavily restored, medieval build-
ing. There was obviously not enough time to visit it properly. But in
order not to lose face, we got out and looked at it briefly over the moat.

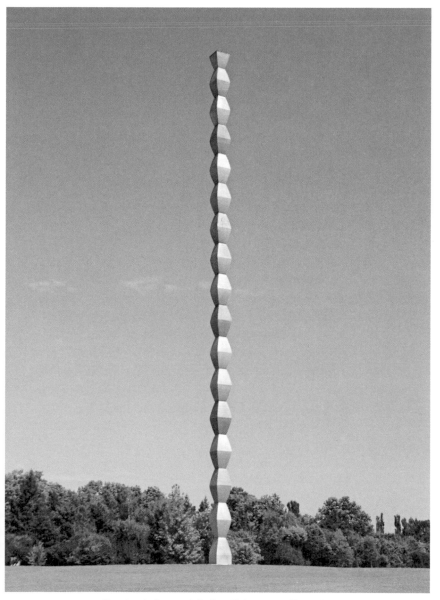

Constantin Brancusi, *Endless Column*, 1938, Târgu Jiu

Then we went back to the car park where Pavel was eating a sandwich and looking at his watch. The sun had gone in and we were now considerably behind schedule.

From that point, it got really slow. We were stuck behind lorries; the pass through the mountains seemed interminable. Morale in the car plunged. Josephine, who had pencilled in a stop at a place famed for making ceramics after we saw the Brancusi, speculated at intervals that there would probably no longer be time for this. Pavel observed that there was still a good way to go. Lunchtime came and went.

We descended from the foothills of the mountains and began to approach the town across the plain. Târgu Jiu turned out to be very well provided with outskirts. Anyone thinking of making a visit should be warned that – modern art aside – its attractions are limited. Our guidebook mentioned that there were 'grim coal and lignite mines' in the environs, plus the 'gross modernization' the place had suffered in the era of the Communist dictator Nicolae Ceauşescu. There was, indeed, a lot of concrete to be seen. I embarrassed myself at one point by mis-identifying a distant factory chimney as Brancusi's *chef d'oeuvre*, but neither Pavel nor Josephine seemed surprised at my mistake.

Eventually, slightly unexpectedly, we arrived. Simultaneously, the weather improved and everybody's spirits rose. There was the *Endless Column*, sprouting out of a small park, gleaming softly in the sunshine, its surface a soft gold. Josephine and I got out to take a closer look; Pavel, who had mused earlier on that it was strange he had never seen this famous monument of Romanian art, elected to appreciate it from the car.

As Josephine and I walked towards it, she remarked that, after all, it had been well worth the journey. Then, when we got within a few feet of the base, a uniformed man with a walrus moustache emerged out of the bushes, waving his arms. Approaching too closely, as it turned out, was forbidden, but that did not really matter. We were there, so near that we could feel as well as see it, and that was the justification for this entire Odyssey, and now we had finally got here, it did not seem a mad thing to have embarked on at all.

Like much abstract art, the column is hard to describe; indeed, it is easier to say what it is not like. It does not resemble the factory

chimney I had mistaken it for, nor a tower or a pillar. The *Endless Column* is lighter, thinner: more like a thread or a chain. It consists of seventeen and a half repeated elements made of iron, rhomboid and chunky, suggestive of a crystal or a massive bead. They stretch up and up into the sky, the most important being the one at the top – the half – because it suggests the meaning of the whole.

This is a sculpture of infinity. It is thus a highly paradoxical thing: a solid three-dimensional representation of time. That is one reason why, like a lot of good art, it is hard to photograph. The result is a picture of a long, thin object sticking up in the air. But the crucial point when you are standing near it is the way it just soars up and up above you. In fact, it is a little short of 100 feet high, but its delicacy makes it seem much more than that. In grandiloquent moments Brancusi described it as a 'stairway to heaven'.

Originally, the column and the other Brancusi works at Târgu Jiu were commissioned by the Women's League of Gorj – the surrounding region – to honour the fallen of the First World War, in which hundreds of thousands of Romanians died fighting Austro-Hungary and Germany. In 1916, many had fallen defending Târgu Jiu, and these were to be commemorated by the new sculptural ensemble.

This was home territory to Brancusi. He was born in 1876, in Hobitza, a little village in the foothills of the Carpathians not far away. His parents were peasants, and the youthful artist showed a talent for woodwork, a popular craft of which you see spectacular examples in Romanian villages. In the folk-art museum at Cluj we had seen wine jars, oil presses and animal traps that looked like bric-a-brac from Brancusi's studio. Looking at these, you realize why he had not needed the ethnographical collections of Paris, which had amazed and instructed Picasso. In Montparnasse these gnarled, timeworn objects would have looked like 'primitivism', but to Brancusi they were simply the implements he had grown up with.

Astonishing height is also, we had discovered, a Romanian thing. The wooden steeples of the 17th- and 18th-century churches in the northern region of Maramureş, near the Ukrainian border, shoot precipitously skywards, needle-sharp, covered with pine shingles like dragons' scales.

In his youth Brancusi moved from a rural world essentially unchanged since the Middle Ages to the international avant-garde, but managed to retain a sense of his beginnings. It was a long journey. As a boy he ran away from home and worked in a grocer's and a bar before his talent was spotted and he made his way first to a school of crafts, then to art school in Bucharest and finally – allegedly on foot – to the Paris of Picasso and Matisse. As a sculptor, he was the only true rival to those giants of the early 20th century.

Doubtless Brancusi had strong feelings for this area around Târgu Jiu – his homeland – and its people. Nonetheless, it is pushing the facts to claim (as Wikipedia does) that the column symbolized 'the infinite sacrifice of the Romanian soldiers'. In reality, the sculpture had developed in Brancusi's mind over many years: it was something he was driven to make. He carved his first column from an oak tree in 1918; it stood over 20-feet high in the garden of the American photographer Edward Steichen. Others followed, but the one at Târgu Jiu is by far the highest, though not too high. Intriguingly, Brancusi made plans for an even taller column, but he went no further. Seventeen and a half beads was just the right number, apparently, to suggest infinity.

It certainly worked. As we stood beside it, the column appeared to be heading for outer space. In the end, Josephine made a short film of it on her phone, scanning upwards, which conveyed the experience better. I sent it to a sculptor friend, Antony Gormley, and he replied a minute or two later with one-word: 'Wow!'

That is a reasonable response. This is obviously an artistic wonder of the world, a magical thing. It is also a perfect demonstration of my firm belief: that when it comes to works of art there is often no substitute for being there, right in front of it. With the *Endless Column*, its whole point is its verticality, its height relative to yours – and also the way it does not merely stretch upwards, as that factory chimney would, but somehow creates a sort of force field around itself, popping out from its surroundings, just seeming to hang there: as if suspended.

Years earlier, the British sculptor Philip King had explained to me how that worked, with the insight of someone who spent his life making abstract forms. 'The individual beads are also just the right height and shape so you don't read the column as narrowing towards

the top, which you would expect to.' 'So', King had gone on, 'it remains an *abstract line in space*, almost a shaft of light, with a strange anti-perspective, and anti-mass.'

I looked up his words before we set out for Romania, and what he said was true, although Philip admitted he had never actually seen the *Endless Column*, which was a point against my being-there theory. But even so, as I stood next to it, it seemed to me that understanding something at a distance and experiencing it physically in front of you are different things.

Actually, in a way, when you are next to it, you understand it even less, while simultaneously experiencing it more strongly. Every time the sun goes behind a cloud or you shift position the whole thing alters. Unlike an earthbound cube, sphere or block, it is just too vertical and lofty to get your head around. And that is part of the point.

To Philip, the *Endless Column* was 'the most spiritual and ethereal of modern sculptures'. He was right and we are lucky it has survived. It did so largely because it is so sturdily constructed. Under the postwar Communist regime the Column was ordered to be demolished, as an example of 'bourgeois decadence'. Obediently, in the 1950s, the mayor of the town tried to have it pulled down by a sturdy Russian tractor (or, according to other accounts, a tank). Fortunately – and amazingly – this did not succeed. This attempted vandalism failed because, although the column stretches towards the sky, Brancusi also carefully anchored his masterpiece in the earth. He had a shaft of steel embedded deep in the ground, and welded each of the cast-iron beads to that.

However, despite all Brancusi's precautions, by the 1990s the *Endless Column* was in a bad state. It was tilting at an angle and so cracked that rain was seeping inside. As a result, the central steel spine was corroded and there were forty gallons of rusty water inside. There followed a long and controversial restoration in which the original steel core was replaced by a new one of stainless steel.

After we had spent time taking in the *Endless Column* from various angles – far away, and as close as the man with the walrus moustache would allow us to venture – we went on to see the rest of Brancusi's ensemble. His idea was that the spectator should walk the mile or so between the column and the other works through a park, with the

Carpathian Mountains in the background. But over the decades, grass-land and fields had developed into busy city streets. Time was pressing, so we fell in with Pavel's suggestion that we should drive there rather than walk. He dropped us on the wrong side of a main road in the centre of town, and, having a limited appetite for modernist sculpture, went off to eat a pizza. After dodging an endless stream of speeding motorists, almost as close packed as the iron beads on Brancusi's column, we entered the wooded park where two more Brancusi works – *The Gate of the Kiss* and *The Table of Silence* – are sited.

The former, a limestone arch made up of highly abstracted versions of embracing figures, is a masterpiece only slightly less striking than the *Endless Column*: a sort of modernist Arc de Triomphe, but with imagery of love, not war. In Romanian villages we had seen magnificent wooden gates standing in front of houses, which were more than a little like *The Gate of the Kiss*, but again, as with the column, Brancusi had taken a traditional form and made it radically new. Here was another argument for being there: the journey had shown us how Romanian Brancusi had been, as well as how modern.

We decided to return from Târgu Jiu by the slower road, which turned out to be slightly faster, although, as our long-suffering driver noted, it took us along the most dangerous highway in the country: a narrow, snaking route infested with Kamikaze over-takers. En route we managed to stop at the pottery town after all, where there were bowls and jars on sale that Brancusi would probably have recognized, and approved. When we arrived back at Sibiu, eleven hours after we had set out, Pavel asked us to wait in the car for a moment. We suspected that after this epic drive, he was, justifiably, going to give us an increased bill. Actually, he had gone to fetch a present – an ornamental model of the picturesque old buildings of Sibiu – but really we should have given one to him.

2 In the Land of the Dancing Lord

At the temple of Annamalaiyar at Tiruvannamalai we ventured down a stairway. It led from a pillared hall into a dark crypt. There, in the flickering light of flames was a garlanded statue of the god Nandi, the young bull who serves as gate-keeper to the Lord Shiva. Along with a succession of fellow visitors, we received a mark of fragrant ash – or *tilaka* – on our foreheads, and a blessing from a bare-chested priest. He offered us daily prayers for twenty years on our behalf for an on-the-spot donation of £50 or so, a bargain offer we politely declined.

Outside there were bustling crowds of pilgrims filling what amounts to a sacred city; the Annamalaiyar temple covers ten hectares. We looked in vain for the temple elephant – apparently off duty at that time in the late afternoon – but there were musicians in robes performing on the giant reed instrument known as the nadeswaram. Scattered around the precincts were numerous sadhus, or wandering holy men, living like medieval friars by begging, and often splendidly bearded and whiskered and clad in orange and saffron robes. Altogether, wandering around this temple was not much like a visit to an art gallery.

*

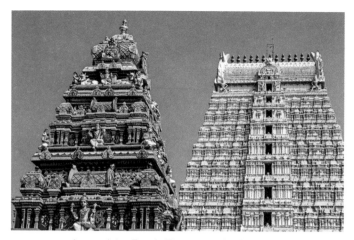

Annamalaiyar Temple, Tiruvannamalai, Tamil Nadu

We had come to Tamil Nadu, the state that occupies the south-
eastern tip of the Indian sub-continent, to see sculpture – and we cer-
tainly did that. The temple at Tiruvannamalai was inhabited by almost
as many carved figures as living worshippers. On the four gopurams,
or entrance towers, they swarmed so densely as almost to obscure the
architecture; the eastern gopuram at Tiruvannamalai is over 200 feet
high, with eleven storeys of statuary arranged in ascending ranks up
to the top. Within the pillared halls, it was the same: each column
covered with reliefs representing sacred stories and deities.

People who love art and the visual world – the late painter Howard
Hodgkin being an example – often become addicted to India. It is not
hard to see why: the place seems inexhaustible, artistically speaking.
But walking round the temple at Tiruvannamalai did not feel like an
exercise in art appreciation. It was more like a journey in time. This,
surely, was what much of world, including Europe, was like before the
idea of art was invented: packed with figures made by people not to be
admired but to be *worshipped*.

Josephine and I had flown to Chennai. Our first experience of
India was a taxi ride to our hotel through the outskirts of the city just
after dawn. This was enough to alert us to the fact that we were in
a place where the rules of life were changed. Looking out of the car

windows, we saw cows wandering casually in and out of the traffic – and this on major roads around a city with a population approximately as large as London's.

Cows, of course, are sacred animals to Hindus, honoured and revered. They threaded their way as of right between speeding lorries, bicycles, mopeds – the last often bearing sari-clad passengers nonchalantly balanced at the rear as they veered from right to left – and a multitude of other road users. Our driver, Rudi, sped along, weaving with infallible accuracy through other vehicles, some of which were heading straight towards us at speed on the wrong side of the carriageway.

In Tamil Nadu, the 21st century coexists with ways of life carrying on as they have for millennia.

*

This was a very different context in which to contemplate a sculpture of the gods Shiva, Vishnu or Parvati from – say – the galleries of the V&A. For that matter, it was most unlike the home of the critic David Sylvester in Notting Hill, where nearly twenty years ago I had spent a morning thinking about ancient Hindu sculpture.

I'd gone to record an interview, but hardly had we settled down to discuss his opinions about art than the doorbell rang. Outside were two porters carrying a 10th-century Indian sculpture, a male figure, which was very beautiful though lacking its head. David was considering buying it, and it had been brought here to audition, as it were, for a place in his collection.

The rest of the morning was spent finding an ideal position for it amid his possessions. David issued instructions – 'Two inches to the left, half an inch higher' – and the two men from the gallery patiently obeyed. For me it was a fascinating lesson in how much the exact placement of a work could alter its effect.

Such matters were crucial according to the Modernist theory of significant form, propounded by the critic Clive Bell, whereby the expressive essence of art was held to consist of shape, volume, colour and line. Meaning was often ignored. Quentin Bell, son of Clive and the painter Vanessa Bell, was steeped in Bloomsbury doctrine when

he was young. He once told me of a lecture by Roger Fry, another Bloomsbury guru, on some pictures in the National Gallery. At one point, Fry gestured at the agonized body of the crucified Christ with the words, 'This important mass!' – which was ridiculous. On the other hand, Roger Fry, David Sylvester and – for that matter – I all cared greatly about mass and the other elements of art.

David, in his way, led a life as governed by devotion as the sadhus in the temple at Tiruvannamalai, but his existence was dominated by art. Most of his house had been transformed into a private museum. Only the kitchen was a relatively conventional domestic zone, but even that contained an ancient Egyptian vessel carved from the hardest of stone ('First Dynasty?' I hazarded when I saw this; 'Pre-dynastic!' he corrected sharply).

Jewish in origin and – I would guess – agnostic in belief, David took a strictly aesthetic, not to say professional, interest in the Indian sculpture. He repeatedly remarked how wonderful it was to see a museum-quality object such as this in a private house, though eventually he did not buy it (perhaps the price tag of £100,000 proved too much). Nonetheless, he confessed that were he to live in Italy, he suspected that in a year or two he would convert to Catholicism, such was the power of painting and sculpture.

There lies a paradox for a dedicated lover of art such as David or me: we devote a great deal of time and energy in the pursuit of art, diligently visiting museums, galleries, churches, mosques, temples and ruins where it is to be found. But of course much of what we look at was made for completely different reasons by pious Buddhists, Christians, Hindus and Moslems.

The interests of the people who first carved and paid for David's headless sculpture were quite unlike his – or mine as I travelled around Tamil Nadu in pursuit of sculpture. They were devout believers, we were not – and yet, perhaps the art did have an effect. David was doubtless exaggerating when he claimed that eighteen months or so of contemplating the paintings of Giotto, Titian and Caravaggio would convert him to the doctrines of the Incarnation and the Trinity, but maybe by looking you absorb something of the feelings and attitudes of the original maker.

*

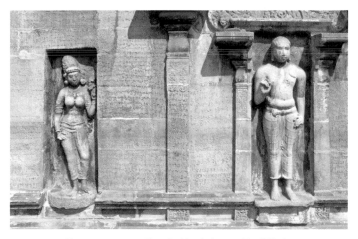

Nageswaraswamy Temple, Kumbakonam, Tamil Nadu

I certainly felt that I was receiving some kind of message when I looked at the stone carvings on the outer wall of the Nageswaraswamy Temple in Kumbakonam. We went there towards the end of a busy day during which we had seen many other things, and for the first time Rudi – normally jovial and helpful – was a little sulky. I said I'd like to go to this place. Josephine was reluctant, because she was in the middle of bird watching from the balcony of our hotel room.

Rudi was against the proposal for another reason: it wasn't on his usual circuit. He'd been driving people around Southern India for decades, and was thoroughly familiar with most sites we visited, but this time he was hesitant. 'What's this place like?' I asked. 'It is another temple', he answered dismissively. But I had read in the *Rough Guide* to India that here in the niches around the sanctum wall were to be found 'a series of exquisite stone figures, regarded as the finest surviving pieces of ancient sculpture in South India'. And so it turned out.

Hidden away at the back of this small building, apparently deserted, were a series of carvings each as subtle, supple and sensuous as the one that Sylvester had enthused over in Notting Hill. They were all 'museum quality', as he put it, and better preserved than that headless torso. An odd aspect of them was that, with the exception of a trio of gods on the end wall, nobody seemed to know who they

represented: possibly donors or contemporary princes and princesses, it was rather vaguely suggested by Wikipedia. Whoever they were, these almost naked women and men had a combination of presence and poise. Looking at them made me want to discover more about the culture from which they had come.

This was the time-machine aspect of art; its ability to communicate across the decades or millennia, in this case over twelve hundred years. These statues convey a sense of grace and dignity through a way of standing, an air of seriousness and certain gestures of the hands, or *mudras*, which in Buddhism, Hinduism and Classical Indian dance have precise uses, at once both spiritual and physical. Some are believed, in yoga exercises, to affect breathing, which in turn promotes meditation – so it involves body and soul simultaneously. Other positions of hand and fingers express states such as enlightenment.

Of all this I had only the haziest understanding, nonetheless the experience of seeing these statues in the quiet temple courtyard was a strong one – far more so than seeing them on a plinth in a museum or in a Victorian house in Notting Hill would have been. However, though tracking down Indian art in its proper habitat was always enlightening, the catch was, we discovered, that it was sometimes difficult to see it there, just as an animal in the wild is much harder to spot than one in a zoo.

*

The great vimana – or pyramid-shaped tower over the inner sanctum – of the Brihadishvara Temple at Thanjavur, 216 feet tall, is visible from far away, rising from the flat lands of the Kaveri River delta much as Ely Cathedral soars above the Fens near my home in Cambridge. The difference is that, when you walk into one of the great shrines of Tamil Nadu, you enter a place resembling the great church at Ely as it must have been five hundred years ago, before the Reformation. That is, they are crammed with bustling pilgrims, indigent holy men, the sounds of sacred music and the odour of incense.

Inside, the sanctum, according to the Michelin guide, contains 'stunning' 1,000-year-old paintings, although it warned that a torch

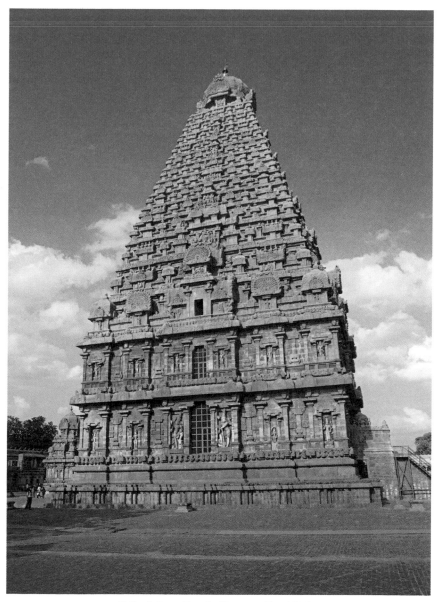

Brihadishvara Temple, Thanjavur, Tamil Nadu

was required to see them. However, amid the darkness, music, scents, reverent worshippers and priests, we lacked the nerve to start shining a light on the walls. Even if we had, the necessary conditions for a calm contemplation of these murals were just not there. We didn't even try.

There is a paradox here: the purpose of a great number of the things we call 'works of art' was and is religious. But when we encounter them in the circumstances for which they were made our reaction – or at least mine – is to feel awkward, a bit embarrassed at being there under false pretences. This is, perhaps, the mirror image of the bewilderment felt by a true believer at finding a sacred image in a museum, lined up with pictures of landscapes and kitchen tables.

*

Art appreciation of the ancient sculptures of gods, still often preserved in the inner sanctums of temples, can be yet harder. The supreme achievements of the Chola dynasty, which ruled this part of Southern India around the time of the Norman Conquest of England, were not carvings in stone, nor even their mighty temples, but figures cast in bronze.

This was a period of intense spiritual revival, during which many Hindu saints preached and composed religious poetry. One of the most prevalent rituals was a procession in which images of the gods were paraded through the streets – a custom that continues to this day. Lined up behind one temple at Kumbakonam we had seen the chariots in which the deities still ride: huge wooden vehicles covered with carvings and roofed with brightly coloured awnings.

For this purpose bronze statuettes were more practically convenient than stone, and they were made in quantity. The ruler Rajaraja I and his family donated no fewer than sixty to his grand Brihadishvara Temple at Thanjavur. It is believed that not only do these represent the gods, but also that – after the correct rituals – the gods themselves inhabit them. In a sense, they *are* Shiva or Vishnu.

In his book *Nine Lives: In Search of the Sacred in Modern India* (2009), William Dalrymple talked to a sculptor in bronze who still made such figures for sacred use in the same way and following the

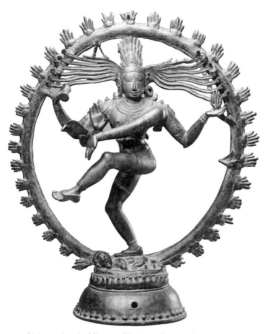

Shiva as Lord of Dance (Nataraja), c. 11th century

same patterns that have been used since the time of Rajaraja. This man described how, even though he had made them himself, when he saw the statuettes again on a temple chariot he felt he was in the presence of divinity.

Once they are taken out of the temple, and put in a museum, for this pious artist-craftsman, the bronzes lose their divinity. That is a very different experience from any that Josephine or I, or any outsider, could possibly have. For us, the idols, still tucked away, robed and anointed in temple sanctums, were impossible to see.

The opposite was true of the museum at Thanjavur, sited in part of the palace of the former Maratha rulers, which houses the world's greatest array of Chola bronzes: case after case of them, room after room. Some are a little worn from hundreds of years of ritual bathing, but a millennium after they were made, many look almost new. We lingered there for an hour or more, looking at figures of Shiva, seated

apparently at ease with his consort Uma (or Parvati), the elephant-headed Ganesh, Vishnu, Krishna and others in the Hindu pantheon.

There was a further divergence, however, between the bronze caster's feelings and ours. He regarded the figures as most charged with force when the ceremony of chiselling open their eyes had just been completed, and the god had recently taken up occupation. The god might remain there for centuries, but eventually – he believed – the divine presence faded away.

For us, not seeing with the eyes of faith, it was the opposite. The earliest of the bronzes were the most powerful. Although they continued to be made in very similar ways, as rules for the modelling of every detail of their appearance were laid down, as time went on the vitality and visual energy somehow slowly ebbed from the forms.

The most celebrated of all Chola creations presents Shiva as Nataraja, the Lord of Dance, creating and destroying the cosmos in a cyclical, rhythmic ecstasy – one leg raised and all four arms held above his head. In one hand he holds a flame, denoting destruction, in another a drum whose sound stands for creation. Around Shiva is a circle of flames; his matted dreadlocks fly out in a fan shape like a peacock's tail, and there, if you peer closely, you can see the mighty river Ganges, nestling in the form of a water nymph. In the museum at Thanjavur there is a whole gallery of Natarajas, each subtly different and essentially the same.

Although it looks very different from Brancusi's *Endless Column*, the Nataraja is also a three-dimensional image of time, the universe surrounding the god in a ring of eternity, perpetually created and destroyed. It represents an idea – that movement and rhythmic energy are fundamental to the universe – echoed by modern physics. When, in 1915, Auguste Rodin saw a photograph of a bronze Nataraja, he wrote that it was the 'perfect expression of rhythmic movement in the world'.

Eventually, we left the museum and went back to the heat of the street, where Rudi was waiting to drive us away through the town. Like all Indian communities we saw, it was pulsing with activity – pedestrians, scooters, vans, porters with barrows, pantechnicons, buses and even occasionally a god on a chariot with a small precession – a mêlée that was not so much rhythmic as chaotic, but probably also eternal.

3 An Audience with Marina Abramović

Tracking down the performance artist Marina Abramović was far from easy; in its way it was almost as challenging as visiting the *Endless Column*. I was in Venice covering the Biennale, and a newspaper had commissioned me to talk to her while I was there – but finding her was another matter. She was staying at the top of a huge Venetian palazzo, tucked away in a maze of back-alleys, the address of which was far from easy to locate. To complicate the search, she had switched off her mobile phone.

For a while I wandered about, disorientated, in this Venetian labyrinth. Then, just as I was about to give up, she finally answered her phone; and it turned out I was standing in the courtyard of the very Renaissance mansion in which she was staying. A minute later she emerged, beaming, 'You are genius to find this place!'

Abramović herself had been on a longer and more complicated journey to her present position, which she sometimes described as 'grandmother of performance art'. She had been born in 1946, sixty-three years before we met, in Belgrade, the capital of what was then Communist Yugoslavia. From there she moved to Western Europe in

1975 and rapidly became the best-known star of a new international movement: performance art.

Almost everything she did involved her own body, often in the most exposed and excruciatingly uncomfortable circumstances. In the cause of art, she had cut her flesh with knives; suffered near-fatal suffocation; starved for twelve days while living entirely in public in a New York gallery; whipped herself; and lain naked on ice.

The list of torments went on and on. Over the years, though her medium was ephemeral, her prestige had grown and grown. The year after I met her, her work was the subject of the first ever retrospective of performance art. At the Museum of Modern Art, New York, teams of younger artists re-enacted her earlier pieces, hour after hour, day after day, for three months.

It was hard to connect all these startling and dramatic images with the friendly woman who led me up the stairs of the palazzo: a talkative person who seemed anything but austere – indeed, cheerily well balanced – and looked remarkably youthful for her years.

'I do these difficult things', she told me after we settled down on the *piano nobile* over cups of tea, 'but I'm in pretty OK shape. I train, I don't smoke, I don't drink – not on principle but because I hate alcohol, it gives me a headache. Performance makes me happy.'

I must admit that at first I found it hard to comprehend a frame of mind in which one would freeze and lacerate one's own body, but draw the line at, say, a glass of Prosecco. But, then, I had also to admit that performance art was a mysterious form to me.

All my life, the kinds of art I have responded to most naturally are static and traditional, painting and sculpture; they last for centuries, not hours and minutes, and are made of materials much more enduring than human flesh. The more I listened to Abramović, however, the more I began to understand. For her, it seemed, performance involved altered consciousness, almost entering a state of trance. 'If I cut myself chopping garlic in the kitchen, I cry.'

'In private life', she went on, 'you feel fragile, you are working from "low-self" – or an everyday state of mind. But when you are doing a performance you can use the energy of the public, which is enormous, to push your limits much further and do whatever you want.'

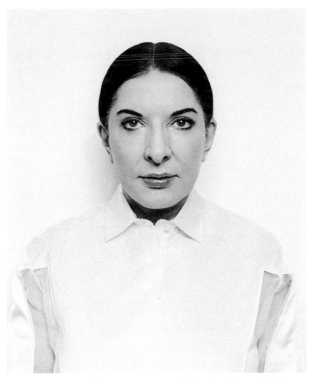

Photograph of Marina Abramović by Paola + Murray, 2015

As Abramović described it, performance art sounded somewhere between therapy and a spiritual exercise. She felt it had a direct power to move viewers that much contemporary art had lost. 'If you are completely open, vulnerable and exposed – Wow! it's incredibly touching', Abramović told me. 'When I was doing my piece *House* in New York, where I go for twelve days without eating, 1,200 people came to look at me and cry. They would come again and again.'

Her objective was not suffering but liberation. 'It is extremely painful to sit for hours without moving; but if you carry on, then you come to a point where you are ready to lose consciousness, and the pain completely disappears', she clicked her fingers: 'nothing. Then you understand that it is possible to take it away, it's in the mind. The pain is like a door and there is amazing freedom on the other side.'

In 1977, Abramović and her then partner, Ulay, sat, silent and almost motionless, in a gallery in Bologna for seventeen hours. They were looking in opposite directions, but connected by a bridge of hair. Hers, extended into a ponytail, was linked with his. It was a metaphor – for togetherness, and separation – and an extraordinary feat of endurance. For the final hour, spectators were allowed in to watch.

A black-and-white film survives of this work, which was entitled *Relation in Time*. Sometimes, even less of a record survives. These days performance is undergoing a revival, like other aspects of seventies life. The tricky point though, Abramović agreed, is how to preserve such a transitory form. 'It has to be live, if not all that remains are bad photographs in books and very boring videos, because in the old days the camera was bad, the sound was bad, bad everything. Nobody looks at that. So if young artists can re-perform my old pieces, who cares if it's "mine"? Let it happen.'

It struck me that there was a link between what Abramović did and religious rituals and ordeals in many cultures, including the mortifications of Christian saints. She at once agreed. 'I was always fascinated by Athos, the Greek holy mountain where only men are allowed to go. I always thought I would have to dress up in some way with a false moustache to see it. There were monks living in holes in the cliffs, with crosses sewn on their chests, eating hardly anything.'

In fact, she had a direct family connection to this kind of faith. Her maternal grandfather had been a patriarch of the Orthodox Church, who was declared a saint. His body was embalmed, and displayed in St Sava's church, Belgrade.

Some of the things Abramović does in performance – such as remaining motionless for lengthy periods and fasting – recall the austerities of Orthodox hermits such St Simeon Stylites, who lived on a pillar in the Syrian Desert. Most saints, though, would have drawn the line at her piece called *Role Exchange* from 1975. In this she changed places for four hours with an Amsterdam prostitute.

'When I look back at my early work,' Abramović mused, 'it was a strange mixture – a very strong asceticism and on the other hand a sort of heroism.' Slavic culture, she explained, is like that: 'It's all about legends, passions, love and hate; very much to do with contradictions.'

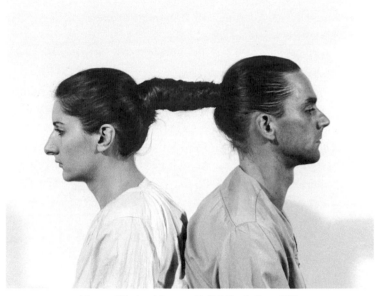

Ulay and Marina Abramović, *Relation in Time*, 1977.
Performance, 17 Hours, Studio G7, Bologna, Italy

Her parents were not religious hermits or ascetics but warriors, who fought with the partisans against the Nazi forces in the Second World War. Each of her parents had saved the other's life during the war, but their backgrounds were very different. Her father, who came from a poor background, left the family when she was 8. Abramović remembered he would barbeque pigs in the bathroom, while her mother went to see the Bolshoi ballet. 'It didn't work at all. I spent most of the time when I was small with my grandmother on my mother's side; she was really religious. There was always a big conflict between her and my communist mother, which continued with me and my mother later on.'

'So', she summed up, 'my grandfather was a saint and my mother and father were heroes, which makes me', here she paused and laughed, '…a complete puzzle.'

Abramović was evidently an unusual child. 'My first attempt to become holy', she told me, 'was when I was staying with my grand-

mother. There was a marble holy water stoup at church and I climbed on a chair and tried to drink it all. The only effect was that I got diarrhoea, because it was really dirty.'

'From the beginning I had the idea of being an artist. What was strange about me was that I was never interested in playing with toys, as other children would do, or with bears and puppets. The only thing I was really interested in was covering myself with a sheet, then sticking my feet and hands out and making shadows against the light.'

She had her first painting exhibition as a teenager, and by the late sixties she was a student at the Academy of Fine Arts in Belgrade, producing paintings of the sky. Then one day she saw a flight of military planes zoom past, and thought that their vapour trails made a wonderful aerial drawing. 'I went to the air base and asked if I could borrow fifteen of their planes to draw with. They phoned up my father and said, "Your daughter's insane."'

'That was the moment of revelation. I couldn't paint any more. It was a tremendous shock: Why should I do something two-dimensional when I can work with all sorts of elements? My first performances were all to do with sound. But then the body was part of the process, because it produced the sound.'

Her body produced noises, moreover, in alarming ways, hard for the squeamish to watch. *Rhythm 10*, from 1973, for example, involved her playing a Russian game with knives. Very rapidly, she jabbed a knife between the splayed fingers of her hand, making an irregular tattoo of drumbeats, interspersed with gasps of pain. Each time she cut herself, she'd then pick up another blade from the twenty spread out before her.

Other performances were positively life threatening. At the climax of *Rhythm 5* in 1974, she leapt into the centre of a large star, emblem of Communism, which was drenched in petroleum and in flames. Once there, she lost consciousness because the fire had sucked the oxygen from the air. Fortunately, a doctor in the audience noticed what had happened and she was rescued.

Not surprisingly, in Belgrade in the late Tito era, this kind of behaviour raised some eyebrows. 'Doing performances in Yugoslavia then was like the first woman walking on the moon. It was not easy and very contradictory because I was extremely shy.' As a young woman,

Abramović went on, she was so self-conscious that if someone was walking down the street behind her, she had to stop and look in a shop until they had passed. 'When I started doing work with the body it was so unbelievably satisfying for me that I could not do anything else. It was really great, because it gave me so much strength.'

But why such frequent self-torture? 'Working with your body, you have to confront your fears: fear of pain, fear of mortality, these are themes of art that have always been there in different forms. If you work with the body you have to deal with them: what does the cut body look like, how far can you push the body's limits?'

While Abramović was doing these extraordinary things in public, she was still – rather amazingly – subject to firm family discipline at home. Her mother had imposed partisan-style order in the household, so after performing extreme acts in the name of art, Abramović would have to rush home to bed. 'Every day I would have to be back by ten in the evening, because only bad women were out after that. Everything had to be washed with detergent, even bananas.' At 29 Abramović ran away; her mother asked the police to haul her back, but they just laughed when they heard how old she was.

From the repression of Belgrade, she moved to the liberation of seventies Amsterdam. 'That was hell for me,' she recalled, 'it was such a shock to go from total control to complete freedom.' In Yugoslavia, she had been oblivious to sixties and seventies counterculture, listening to Bach and Mozart rather than the Beatles. 'Though it was the time of rock and roll and drugs, all that didn't exist in my life.'

Next she met a German performance artist, Ulay, who was born on the same day – 30 November – as she had been (but three years earlier, in 1943). They embarked on a twelve-year relationship and experiment in pooled artistic identity.

Abramović and Ulay dressed – or undressed – alike, and performed joint works together. Their final piece in 1988 marked their break-up. Each walked half the length of the Great Wall of China, he starting from the Gobi Desert, she from the sea. 'We went through thirteen provinces, saw incredible poverty and incredible cruelty.'

They met in the middle and said goodbye. Originally, she explained, the plan had been for them to meet and marry, but the whole operation

took so long to set up – negotiations between the Dutch and Chinese governments – that by the time it was agreed, their relationship was over. The marriage, she explained, was his idea.

The relationship was put under strain, she thought, by her celebrity: not surprisingly, as her originality as an artist was complemented in her youth by the looks and presence of a film star. 'Because I was well known, people would write about the work and not even mention his name. I've always had this kind of curse, this attention on me all the time, which breaks up my private life totally.'

She had, she went on, never been 'into marriages' – 'They always want to marry me, then to change me and it doesn't work!' – and had never wanted children. It was a total sacrifice: nothing should divert attention from her art. 'That's why', she added unexpectedly, 'I'm thinking an astronaut is my best choice as a husband, because he'd be in space doing anti-gravitational experiments, and I could work undisturbed.'

After our conversation, I wandered back from the secluded palazzo where she was staying and into the whirlpool of the Venice Biennale. But I returned slightly changed. Suddenly, I could see the point of a type of art that had previously been mysterious to me. I saw that a painter such as Vincent van Gogh suffered and made sacrifices for his work, almost like a hermit. And I understood that all art is a kind of performance, even if its result is more long lasting. In fact, as sometimes happens on meeting a remarkable artist, I had experienced a conversion.

A conversation can have the same effect as going on a journey: you are physically in the same space as another person, looking at them and sensing their personality as well as hearing their words. It makes a difference. In New York the next year, Abramović performed a work in which she sat for three months at a wooden table while members of the public took turns to sit in the chair opposite and silently meet her gaze. It was called *The Artist Is Present*. She was, of course, during our interview too.

PREDECESSORS, RIVALS, SUCCESSORS

4 Cro-Magnon Days (and Nights)

We arrived at Les Eyzies at the very end of the season. Even in the rural Dordogne the weather was damp and autumnal, the evenings distinctly chilly. Nonetheless, I could see advantages in our timing, which was accidental, the result of putting off booking until the very last moment. In a few days the ticket office would close and it would be impossible to visit the prehistoric sites until the following year.

The upside of being there in the last few days of October, I speculated, was that there would not be many other people trying to see the same sites. Visiting these, especially one of the few caves containing paintings tens of thousands of years old, had long been an aim of mine. It was made more urgent by the fact that I had just embarked on a book, co-written with David Hockney, which was intended as a history of pictures from the cave wall to the computer screen.

Before writing my part of that text, I felt I simply had to stand in front of a few at least of these prehistoric paintings and drawings: to see them, not in photographs, but in reality. In summer, I knew, the better-known caves were extremely popular, so much so that it was

difficult even to get a ticket. Surely, though, I reasoned, in these quiet days, with winter just a few weeks away, there would not be many holiday-makers hereabouts.

Josephine and I flew to Bergerac, an agreeably low-key airport, which did not consist of much more than a few huts and a field, and picked up a car. By early evening we had checked into Hôtel Cro-Magnon, a pleasantly old-fashioned looking building, at one end of the village, which turned out to be a long, thin place, arranged along a single road that ran beneath a cliff.

We took the name of the hotel to be a generalized reference to the prehistoric remains scattered all over this area, 'Cro-Magnon' being a slightly archaic term for prehistoric culture in a certain era. It was not until later that we discovered that the establishment had been christened with Gallic precision.

Above, halfway up the cliff, was an overhang in which, in 1868, workmen had found animal bones, flint tools and human remains. Louis Lartet, a geologist who took over the digging from the labourers, found parts of the skeletons of four adults and one child. These were dubbed 'Cro-Magnon Men' – in fact one skull belonged to a women – and hailed as the first modern human inhabitants of Europe. Our bedroom was a few yards away from their rock-shelter: a curiously intimate arrangement. We were virtually living in Pre-History, though admittedly in considerably more comfort.

The next morning we got up quite early as we decided to take no chances about the question of admission. We were outside the ticket office at the other end of Les Eyzies even before it opened at 9 a.m. Unfortunately, so were quite a large number of other people, and we found ourselves at the back of a lengthy queue. Infuriatingly, the line in front actually grew longer after the opening time, since several people, it dawned on me, were keeping a place for half a dozen friends, who were presumably relaxing in the warm.

When we finally got to the desk after about forty-five minutes, it was to discover that there were no more places available that day on tours of either the Grotte de Font-de-Gaume – with wonderful paintings – nor of the nearby cave of Les Combarelles, containing incised drawings on its walls. It began to look as if this entire journey was a

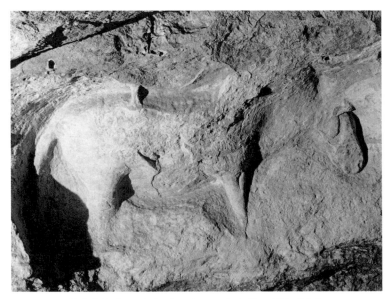

Relief of a horse in the limestone rock shelter at Cap Blanc,
Les Eyzies, Dordogne

waste of time. Almost at random, in a deeply gloomy mood, we chose to go to a rock shelter a few miles away: the *abri* of Cap Blanc.

There was a brisk exchange of views in the car while we were en route about whether we should have tried harder to book some of the limited number of tickets available in advance. This was possible in those days, though we could not work out from the website how to do so (nowadays it is impossible, which simplifies the matter).

Morale was low and conversation a little clipped when we arrived at the *abri*. We waited for our tour to begin, meanwhile looking at a small display of finds from the site, which did not improve my mood. Although I am extremely fond of art, I am not so enthusiastic about archaeology. Cases full of bone and fragments of ancient, brownish ceramic do not excite me. Years ago, on a family holiday to Greece, our children came up with a generic name for this kind of place: 'The Museum of Boring Pots', and I inwardly sympathized with them.

The most important find made at this site – the almost complete skeleton of a young woman known as the Magdalenian Girl – was not

on view here at all, we gathered, but at the Field Museum, Chicago, which had bought her bones in 1926. She has now been subject to a high resolution CT scan and her appearance reconstructed by a sculptor: a process from which she emerged looking surprisingly glamorous in the manner of reality TV and wearing a natty headdress of beads.

Eventually, a guide appeared and ushered us, and a small knot of other visitors, through a door at the back of the little building – and there was the *abri* itself. It was a space about 50 feet long, with a sloping rock floor in front of it and a natural roof above. In the middle, quite distinct and almost – the only word was 'naturalistic' – was a horse, much worn by time and carved in high relief; over to the left there were a couple more.

Bit by bit, as the guide pointed them out, I could make out ten horses, plus other animals including ibex and bison. Some of these were hard to distinguish, crumbled away and eroded by wind and rain as they were, but the best – particularly those horses – were astonishingly strong and unexpectedly big, too.

A couple of years before, I'd seen a lot of beautiful small-scale prehistoric sculptures in an exhibition at the British Museum. Those, however, were carved on mammoth tusks and bits of bone, and measured in inches. The largest horse at the Cap Blanc rock shelter was around six feet long, getting on for life-size.

Here was – the word came into my mind as I looked – an installation, some 15,000 years old. It was not hard to imagine how it would have appeared in the light of a flickering fire or a slanting evening sun. In fact, picked out by the guide, who manipulated the lighting and moved his torch from place to place, it was still pretty fabulous.

The question then arose: how to occupy the rest of the day, which we had expected to spend in the caves for which we couldn't get tickets? After consulting the guidebook, we decided to take a look at the full-sized facsimile of the painted caves at Lascaux, the most celebrated array of prehistoric art in the world, but not a site that anyone, bar a few experts, could actually visit.

The cave had been discovered in 1940, and became, understandably, a huge attraction in the years after the war. By the mid-1950s some 1,200 people a day were walking past these spectacular murals,

as opposed to the daily allocation of seventy-eight still allowed into Font-de-Gaume. People are, of course, a form of pollution: the heat, moisture, carbon dioxide and micro-organisms carried in by art-lovers rapidly began to damage the paintings. Lichens and crystals grew on them. In 1963, Lascaux was closed to the public.

As a substitute, Lascaux II was created: a minutely accurate copy constructed on almost the same spot; you pass the sealed door of the real caves on the way in. The copies of the pictures, and even the configuration of the walls, moulded in silicone, are exact.

Lascaux II should therefore be a perfect duplication of the experience of seeing the real thing; it is certainly a highly popular one. Outside we found an enormous car park. There were tour buses and school parties. Getting tickets even for this copy of prehistoric art was no easy matter. But although enjoyable and enlightening, it was not quite the same as seeing the real thing.

Years before, musing on the difference between looking at a photograph of a painting and the thing itself, the artist Jenny Saville made this point to me: 'When you are in front of a painting, you're in the place where whoever made that work was.' Looking at an original Rembrandt or Velázquez, therefore, is a limited form of time travel.

You enter the same space, relative to the picture, as the painter. The visual information passing through your retina and down your optic nerve will be much the same – except for physical changes in the paint surface – even if the assumptions and beliefs inside your head are not.

Perhaps at Lascaux II subtle cues revealed that I was looking at a silicone membrane rather than rock, perhaps the process of entering made it feel more like visiting a museum than descending into the bowels of the earth. Of course, there is no choice; the only way to see Lascaux is in some kind of reproduction.

It's the same with Chauvet, an equally spectacular cave discovered in 1994 in the Ardèche region. This was sealed early on. It can be entered only by specialists, clad like spacemen in protective clothing, intended, of course, not to shield them from the cave, but it from human pollution.

At home before we left we had seen a remarkable film by Werner Herzog about Chauvet, shot in 3-D, so that when wearing the correct

goggles we got a clear, sculptural sense of every knob of stone and cleft in the surface of the pictures. This is the closest almost all of us will get to visiting the cavern itself. But Herzog's *Cave of Forgotten Dreams* (2010) was not a complete substitute for the real thing. Nor was Lascaux II.

*

We were up even earlier the next day. It was not quite light, and drizzling when we arrived outside the ticket office. There was already a queue, but this time it was considerably shorter. Eventually, the lights went on inside and the door opened. I became alarmed as, again, it turned out that the person two ahead of us was saving a place for five friends. It looked as if it was going to be close, and it was. But by nine thirty we had secured places – among the few remaining – on tours of the caves we most wanted to see: Font-de-Gaume and Les Combarelles.

A little later, after coffee and croissants in a cosy café, we were back, waiting by the book display in the office with the other ten people in the group. The guide appeared and led us up a slanting path behind, around a cylindrical buttress of rock like a section of castle wall, and along a little wooded valley. We paused for a while outside two entrances, high up on the slope. The one on the left is shallow, we learned; just a shelter for sheep. But the one on the right goes deep into the hill.

As soon as we got inside, several reasons for limiting access – apart from the damage caused by the gases and moisture in our breath – became apparent. The cave is narrower than Lascaux, the best of the paintings hundreds of feet inside, the floor uneven, the roof sometimes low. But these hazards to visitor health and safety are an enhancement of the Cro-Magnon feeling of it all. Even illuminated by electric light, the sensation of walking into the hill can't be very different from the way it was many thousands of years ago when people made the paintings on the walls; you are close to the wall, intimately near to the pictures and with just a few companions.

Font-de-Gaume was 'discovered' by a local schoolmaster in 1901, but people had been going in long before that, but either did not

notice, or were not interested by, the faded images of animals on the walls. After attention was drawn to the prehistoric pictures, quite a few were damaged by vandals and graffiti. The best are a long way inside, finest of all a frieze of five bison, which was not spotted until 1966. This had been hidden under a mineral deposit that had built up over many centuries. When this was removed, they were revealed looking remarkably fresh.

The guide switched off the lights and swung his torch from side to side, and as he did so, the animals on the wall above us seemed to stir and lumber. In other words, seen in conditions close to those in which the people who made it would have known – by the light of torches and sputtering tallow lamps – this was something close to a movie. The day before, we had gone to a sort of prehistoric zoo, le Parc du Thot, near Lascaux, and seen European bison as well as types of horse and deer that thrived hereabouts in the era of the Ice Age. The evocation of the beasts in the pictures – their weight, thick hairy coat and agile awkwardness – was mesmerizingly strong.

This was a light bulb moment for me. Another came in the afternoon, when we went to Les Combarelles, a little further out of Les Eyzies, and found it to be an even narrower cave – claustrophobically so. Here there are not polychrome paintings, but many – indeed hundreds – of engraved drawings on the walls. Of these, the one that struck me most was a cave lion, another favourite subject of the Cro-Magnon artists – and a doubtless terrifying threat.

The eye of this lion, wide and glaring, was formed by a pebble, itself a natural part of the rock wall. Then it struck me: this, and the undulations in the stone that made the bison seem to shift and sway, had not just been used by the artist to create an effect. I felt sure that these marks and furrows in the stone had suggested images to them: that these caves had been like an enormous, walk-in Rorsach blot for those ancient people.

Or, for that matter, what old, stained walls had been to Leonardo da Vinci. He described how when he looked at such random shapes, he saw landscape and battles. Personally, looking at clouds and damp stains on the ceiling, I most often see faces. The Cro-Magnon artists found what they were most interested in: animals.

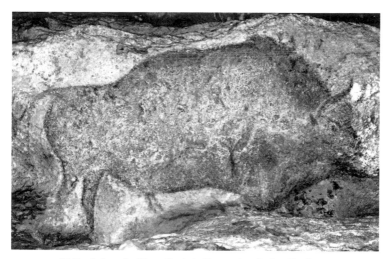

Wall painting of a bison, Font-de-Gaume, Les Eyzies, Dordogne

We do not know, and never will know, why they made these pictures: what rituals or beliefs they represented. In the past few years, it has been suggested that most of the artists were women – the silhouettes of hands to be found in many caves seem to be largely female ones – which is plausible, but, like every other theory about prehistoric art, subject to scholarly argument.

One thing, however, seemed absolutely clear to me as I came out into the weak sunlight of late autumn in the Dordogne. The people who painted these pictures were just like us. They saw the world, and processed the information that streamed through their eyes, in exactly the same way.

It made more sense of what living painters had often told me: that they were doing just what prehistoric people had done. David Hockney mused that one of his ancestors must have been a cave artist. It was a favourite line of Gary Hume's, too: 'I'm a caveman still, in my cave, painting the world out there.' And Jenny Saville pointed out that painting had scarcely altered in 30,000 years. 'It's just pigment and oil, a human being and a mark-making tool.'

5 Jenny Saville: The Moment when a Wave Breaks

'When I see my four- and five-year-old children scribbling away with paint', Jenny Saville told me, 'I realize that – together with singing and dancing – it's one of the most instinctive of human activities.' In a way, talking to her and looking at her work over a quarter of a century has had the same effect on me.

I've known and talked to many painters over the years. But Jenny, as was obvious when you saw her pictures, was the first I'd encountered who was both enormously talented and also from a generation younger than mine. Up to then painting had been something that fascinated me, but which belonged in the past. Many pictures I loved had been made long ago, by Titian or Van Gogh; even the living painters I knew were my parents' age, or at least that of much older siblings. Saville by her very existence was a token that this wonderful medium had a future.

She too, I discovered, was constantly aware of the past, as I suppose you have to be if you are doing something that human beings have done for at least 35,000 years. She enthusiastically talked about Gerhard Richter's abstracts, Rothko, Pollock and Francis Bacon. 'There's a

history and a dialogue. You're in the studio with art books. Velázquez, De Kooning, Picasso...Michelangelo is always there because I've got the same love of things like musculature in legs, the strength that goes through something.'

Being a painter, she explained, was a vocation requiring absolute commitment. 'It's full endeavour, not a question of thinking I could make a film one week, a sculpture the next. I don't want to travel a lot, move around the world. I want to search in *paint*.'

Some artists I've met just once for an interview; others become such good friends that it becomes impossible to count the number of times we've talked. My meetings with Saville come in between those limits. She's someone I've encountered at intervals over a couple of decades, and every time we've spoken what she's had to say has been all about painting. That, plainly, was what occupied her thoughts. Gillian Ayres, another obsessive and brilliant painter, once confided to me, 'Your mind is always on it'.

Saville was obviously just the same. 'I just love the act of painting. I always have done since I was really young, since I was about 8 really. And I try to do in paint what you couldn't do in another way. It is a matter of getting deeply into the medium; that is why it takes a long time. If you are a painter, you often *think* in paint.'

*

It was 1994 when I first saw Jenny Saville. She was stark naked and towering like a giantess in a North London suburb. The place was the original Saatchi Gallery in St John's Wood. For me, in those days, this was a familiar destination; I regularly walked there from the Tube station, past the house once occupied by the slick Victorian classicist Lawrence Alma-Tadema and the fabled pedestrian crossing on Abbey Road, across which the Beatles once strode. The Saatchi Gallery was a little further on, at the end of Boundary Road.

I seem to remember reviewing the show in which Saville appeared – *Young British Artists III* – but can find no trace in my cuttings file or on the Internet, so perhaps I just visited it, off duty as a critic. Her paintings were hung in the central part of the gallery, opposite the

entrance: all big canvases, 7 feet high, of massive, naked female bodies seen from startlingly close up, as if the spectator was only a few inches away from the nearest area of flesh.

These were nothing like conventional nudes. Rolls of flab bulged out at you. Their skin was strangely seamed and marked as if with graffiti, distorted by perspective. They were simultaneously punk and baroque: here was the tradition of Titian and Rubens updated, completely contemporary. I thought they were marvellous. But I did not actually meet Jenny – the person not a picture – for some time.

The Saatchi gallery exhibition almost instantly made Saville famous. Four years later, in 1998, she had left the Saatchi stable and was scheduled to have an exhibition at the New York Gallery of Larry Gagosian, one of the most powerful and influential dealers in contemporary art in the world. There was supposed to be an interview in the catalogue conducted by David Sylvester. But David was ill, and recommended me as a substitute. I was pleased – in fact, flattered – to do it. By then, Saville was working and living in London, in a studio in North London.

There was another art historical echo to those paintings at the Saatchi Gallery, which I did not notice until much later. The grandeur of the bodies, together with their complete lack of eroticism, was faintly reminiscent of prehistoric sculptures such as the Venus of Willendorf or the Venus of Dolní Vestonice. When these were first found, as the names suggest, they were thought of as goddesses of fertility or sexuality like the classical Venus or Ceres. More recently, however, it has been suggested that, like prehistoric painting, these may have been made by women, in this instance as charms against the risks of Ice Age childbirth.

Like all theories about art from such a distant epoch, this idea is highly debatable. But it makes sense of the affinity these ancient female figures seemed to have with Saville's pictures – because, of course, those too were images of women's bodies, by a woman.

Indeed, most, but not all the works I'd seen at the Saatchi Gallery were based, partly at least, on her own body. That was true, for example, of Propped (1992), a naked figure balanced precariously on a sort of tripod. In this, rather than the massive dangling breast and

Jenny Saville, *Propped*, 1992

buttocks of the prehistoric figures, the most prominent feature was a pair of vast legs, shooting forward into space like an overhanging cliff – seen from close up as if the viewer was suspended at knee-level. This, it turned out, was partly based on a photograph Saville had taken of herself: in fact a selfie, although that term didn't appear for another couple of decades.

She told me she used herself because 'I'm convenient: I'm there all the time'. But there was another, more intriguing reason. 'The feeling of being an artist and a model interested me, because in history as a female your position was as a model, largely. Women have been looked at, rather than being the people who look. As an artist, your role is to look. So I was combining those two things.'

These were, however, far from being self-portraits, even if they were partly based on selfies. She introduced bits of other bodies into the mix as necessary, and the final result looked very unlike the small and slender artist I met that day in her studio.

Her reason for wanting to create the impression of a giant form was revealing: to bring the viewer closer. 'It's the effect of *intimacy* I want. Although large paintings are so often associated with grandeur, with big important issues, I want to make large paintings that are more intimate than small ones. I want the painting almost to surround your body when you are looking at it.'

In front of paintings such as *Propped, Branded* (1992) and *Plan* (1993), I'd felt these bodies towered up like cliff faces, which was, it turned out, just what she had intended. 'I wanted to evoke the idea that you had to climb these bodies, as if they were some sort of mountain face; you couldn't assess them very easily. It was almost that *they* assessed *you*.' This certainly worked.

Saville, I discovered, was fascinated by scale. This, of course, is fundamental to painting in a way that is not to many other media. A film, for instance can be shown on a screen of any size. In the same way, a photograph does not necessarily have a particular dimension.

A painting, on the other hand, does – and that makes a difference. Cézanne's remark: 'two kilos of blue are a lot bluer than one kilo' has often been quoted by other painters from Gauguin and Matisse to David Hockney. In a picture size matters: a large area of a colour has a

different effect from a small one. That's because, if you are looking at the original, its impact is physiological. In the same way, standing next to a big tree feels quite unlike being next to a sapling.

So, although you can obtain a lot of pleasure and information about a picture from a photograph, to get the full force of it, you have to see the real thing. The scale of a reproduction is almost always different from the actual picture, so is the colour, and even if those are close, you'll miss the nuances of texture and translucency, the variations of brush-marks, the way light shines through some passages, the opacity of others (here was the same effect I experienced in the caves of the Dordogne).

Saville used to think painting was limited by the fact that the viewer had to be there, in the same room. But, she told me, 'now I think that is its strength. You have to make a physical effort to be there yourself to see it. Your body has to stand in front of it. That's its power. When you look at a painting that's been reduced to 10 by 12 inches it's completely different. A De Kooning in the original blows me over. It's the physicality of his paint; he uses it in a sculptural way. Rembrandt is the same.'

De Kooning and Rembrandt are both painters' painters, much admired and frequently mentioned by people trying to do the same thing. They also made remarkable depictions of the human body. De Kooning famously said that 'flesh was the reason why oil painting was invented'. And Saville is a painter of flesh in the way that Constable was an exponent of landscape – more so: it is her only, obsessive preoccupation.

'That's what has fascinated me and seems to take up all my time. One painting leads to the next, and then to the next.' She wants to convey an emotion: 'the sense of life, of mortality, living in flesh. Painting bodies is an endeavour that continues to fascinate me. I feel it's something that's going to take my whole life to get anywhere near interesting.'

*

A couple of years after that, in 2000, Saville took part in a newspaper series I was doing called *Artists on Art*. She picked *Carcass of Beef*

Chaïm Soutine, *Carcass of Beef*, c. 1925

(c. 1925), a painting by Chaïm Soutine in the collection of the Albright-Knox Art Gallery, Buffalo.

For her, the appeal of this painting lay partly in what it depicted: meat. That is, edible flesh. It is, of course, a subject with a long history, the theme of masterpieces by, among others, Rembrandt, Goya and Francis Bacon, in each of which the equivalence is made clear. Goya's dead turkey takes on the aura of a martyred saint; Rembrandt's *Slaughtered Ox* (1655) hangs suspended like a crucified Christ.

'I already knew Rembrandt's carcass painting before I saw this painting', Saville told me. 'And it felt as though Soutine had gone into the same room that Rembrandt went into, and just got a lot closer.'

As is often the case when artists talk about other artists – or, indeed, when anybody comments on anyone else – what she had said revealed a great deal about her. For example, she liked the way Soutine 'focused absolutely on the body of the carcass, the meat', much as in her own paintings she chose to concentrate 'just on the flesh'.

The way Saville described Soutine's way of painting made it sound like a mixture of skill and instinct, like surfing, for example, or bull fighting. 'It's a matter of doing just enough. To me, that's the tight-rope that people who are painters' painters walk. It's like capturing the moment when a wave breaks. It's so easy just to slip down the other side. Sometimes, if you push too hard, the whole thing falls apart.'

*

The next time I talked to Jenny at length, in 2012, she was living in Oxford. She now had two children, so the rhythm of her days had altered, but not much. She described the routine of a painter/mother. Usually she picked the children up when they'd finished school, made dinner for them, bathed them, and put them to bed. 'They are asleep by about 7.20 p.m., then I go back to the studio and continue until one or one thirty in the morning. I used to work until 4.30 a.m., but that kills me now that I have to get up in the morning.'

Instead, she'd start again at 8 a.m. 'I try to do the complicated bits of my paintings, the ones I really have to concentrate on, first thing. Sometimes I do the most dramatic things at night. Out of tiredness there comes a sort of exasperation. I find that is quite good to use – if it works – otherwise next morning it's, "Arggh".'

'If you are painter it's your whole existence. It's not an activity you can do a couple of days a week, then do something else. It's a bit like being an athlete. You have to keep fit and nimble.' I think that is true of all good painters, and writers and musicians too; for that matter, of anyone who does anything really well. If they don't maintain form, which means constant practice, they risk losing what jazz musicians call their 'chops'.

*

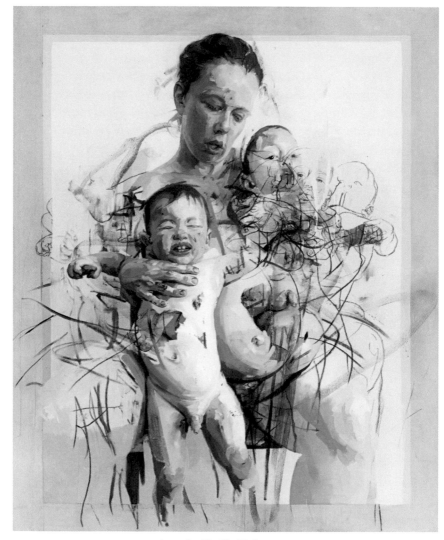

Jenny Saville, *The Mothers*, 2011

Another couple of years passed, and I sat down for another long conversation with Jenny. By then her work had evolved again. Her new subject was a couple, lying together, in a way that related to old master pictures in which reclining gods and goddesses, nymphs and satyrs, were a frequent theme, but her paintings were now just on the edge of abstraction. On a canvas there would be a mêlée of lines and forms, from which at certain points anatomically precise elements would emerge: a rounded upper leg and buttock towards the top, a nipple like a fried egg on a plate, or a couple of protruding feet, drawn succinctly and precisely as they might have been by a Renaissance master.

'I feel much more daring in the way I make work. Now I have two studios, so instead of getting tired in one – when you think, "This is not working out" – downtrodden, I just go to the other. They are across the park from each other. One's got beautiful daylight, really airy and minimal. The other's more a night-time studio: dark, grungy and melancholic.' She would work on several pictures at a time, pushing them further and further until she might destroy a whole section. 'Then I'm off again. The destruction is really part of the making of it.'

She was preparing for an exhibition in Zurich, in which her work was going to hang beside works by Egon Schiele, one of the most celebrated artists in turn-of-the-20th-century Vienna. When told about this, her mother had exclaimed. 'Gosh! You were obsessed by him as a teenage girl.' And Saville remembered that indeed she had been.

Not long afterwards, at a lunch party, I was chatting to the hosts' teenage daughter, who was just off to university to study art. I happened to mention I'd done an interview with Jenny Saville, and this 18-year-old responded that yes, she'd studied Saville's work for A Level. To her, it was obviously much the same as if I'd mentioned I'd been in conversation with Giotto. I realized that Jenny had, without my noticing it, turned into an old master herself.

6 The Sistine Chapel: Judgment and Revelations

On 14 July 2010, I found myself in Rome, oozing moisture at a café table in the shade of the Belvedere courtyard. Sweltering with me were Mark Evans, curator of paintings at the V&A, and a variety of journalists including my friend and fellow art critic Waldemar Januszczak. Father Mark, an urbane young American priest, had been given the job of shepherding us through the corridors of the Vatican.

The rest of the party were clad in light, already slightly sticky, clothes, but Father Mark, like all his ecclesiastical colleagues, was wearing a black serge suit, shirt and dog collar. Nonetheless, despite the scorching and suffocating heat, he appeared perfectly cool. After a while, Father Mark explained, the body adjusts to this costume, even in the furnace of a Roman July.

Everything, it seems, is relative, depending on what you are used to. And we were about to witness a startling change in an immensely celebrated space. Generally speaking, the Sistine Chapel is the best-known one-man show on earth. The largest portion of Michelangelo's painted works is to be found on its walls. The exceptions are three panel paintings, two disputed by some scholars, and two more frescoes

hidden a few yards away from the Sistine, in another chapel, the Pauline, and very seldom seen by any visitor, since this is the Pope's private place of worship.

The Sistine, on the other hand, is seen by multitudes. On average, 25,000 people pour in per day; five million a year, the population of a small nation. The voices of the assembled visitors rise and fall in a murmur like the sea, punctuated by an occasional doleful cry from the attendants of 'No Photograph!' Just moving around the floor can be difficult; finding a seat on the benches along the walls requires cunning and patience.

At any one moment, most of those visitors will be looking up at the vault 70 feet above their heads – and consequently getting a crick in the neck, an ineluctable result of gazing at Michelangelo's ceiling under any conditions. Fewer, but a significant number, will be contemplating his *Last Judgment* on the altar wall, a marvellous work, but not quite so marvellous, in general estimation, as the ceiling. Very few ever look at the 15th-century paintings on the side walls; virtually nobody at the architectural furnishings: the choir loft and screen. Absolutely no one at all ever looks at the late 16th-century frescoes on the eastern wall (though we certainly would be looking in that direction had Pope Clement VII had his way and persuaded Michelangelo to paint the *Fall of Rebel Angels* there).

Today, however, it was going to be different. Art historians, as David Hockney has noted, don't often carry out experiments. But that was exactly what we had come for: a remarkable visual trail was going to take place in the Sistine Chapel. For the first time in decades, Raphael's tapestries were going to be hung there on the hooks inserted in the plaster for them in the early 16th century – and in a different order than on the previous occasion.

The tapestries were commissioned by Pope Leo X in 1515, three years after Michelangelo had completed the ceiling. In the eyes of contemporaries, they were by no means – as they used to say on music-hall bills – a 'supporting act'. For one thing, they were a great deal more expensive. The ten tapestries that were completed cost at least 16,000 ducats. That is, at least five times what Michelangelo was paid for the ceiling (in itself, a massive fee for the period).

Furthermore, many Renaissance critics would have said that all in all, Raphael was the greater artist of the two. Michelangelo could do one thing supremely well – the muscular male nude – but Raphael could paint all sorts of things: landscapes, portraits, harmonious groups of urbane figures, pretty girls. A 16th-century text complained that Raphael painted gentlemen, whereas Michelangelo's figures looked like muscle-bound porters. It was a view that suited an aristocratic age; but Michelangelo's rugged titans appeal more to the individualistic 21st century.

To some Renaissance eyes, at least, the tapestries would have been the chapel's crowning embellishment. Indeed, that was how they were intended: the final touch of splendour, to be brought out for church feasts and special occasions. For centuries, this was how they were used: hung in the chapel and even outside in the piazza on high days and holidays. However, for decades now, they had been preserved behind glass in the Vatican Picture Gallery. They had not been seen in the chapel since 1983, and never in living memory the way we were going to see them.

At lunchtime the chapel was closed to visitors, causing a massive tailback of tourists past which we were ushered through the doors and into a huge room filled with art, and nothing and nobody else. It was cool in there, and thanks to the blazing sun outside, filled with natural light.

While we watched, Arnold Nesselrath, Chief Curator of the Vatican Museums, and his team of specialist art movers went to work. One by one, the tapestries were unwrapped and hung from those venerable hooks. This exercise was not undertaken on a whim but to test a scholarly hypothesis.

Examination of the 16th-century stone skirting revealed that the screen dividing the chapel – originally intended to separate lay and clerical dignitaries in the congregation – had been moved earlier in the 16th century than previously thought. This recondite discovery had a knock-on effect on the sequence in which the tapestries might have been hung.

This itself could seem a small, pedantic point. But everything affects how a picture looks. An alteration in the light makes a difference, so does a different position, or the juxtaposition with other pictures.

Just moving the works around in a gallery or exhibition can bring them to life or alter the impression they make.

As we watched, it became obvious that this new arrangement – the reverse of the one proposed in the early 1980s – was correct. The forms, lines and colours flowed from one image to the next around the walls. But something even more fascinating was happening: a titanic competition – and conversation – between Raphael and Michelangelo was coming into view bit by bit before our eyes.

*

On that baking July day, I was, internally at least, living with Michelangelo. The year before I had begun writing a biography of him. Steeped in his letters, poems and jottings, I was beginning to feel I knew him and, despite or because of his neurotic, driven nature, to like him.

The relationship between biographer and subject, though virtual, is a close one. Towards the end of the process, Michelangelo started entering my dreams. In one of these, around the time I finally finished the book, he offered me a glass of wine, presumably the white Trebbiano, which his nephew Lionardo was always sending him in barrels from Florence. I accepted it as a sign of approval.

Had it been possible to visit his Roman house on the long-vanished street of Macel de' Corvi and talk to him, I felt I could guess, as I sometimes did with living interviewees, what he might have said. He would have been prickly, secretive and suspicious. Doubtless, like virtually all artists, he would have hated being labelled, indignantly rejecting the idea that he was part of something called 'the Renaissance'. He respected his great predecessors, Donatello for example, but tended to have acrimonious relations with living rivals. Leonardo da Vinci he viewed with 'the greatest disdain', and Raphael he seems to have cordially loathed.

One of the traits that made him attractive was a sense of humour, albeit a black one. In the centre of the *Last Judgment*, audaciously, he had drawn a sort of cartoon portrait of himself, on the inside of the flayed skin of St Bartholomew, wobbling above us like a wet suit.

Michelangelo, *The Last Judgment* (detail), 1536–41,
Sistine Chapel, Vatican City

And, unless it was my imagination, as one of the tapestries went up, another of Michelangelo's darkly sardonic jokes emerged.

Fifteen years after Raphael's death, Michelangelo, somewhat against his will, embarked on another huge commission: *The Last Judgment*. With the tapestries, Raphael had commented, visually, on his ceiling. Now here was an opportunity for him to answer Raphael. And I thought I could see a place where he had done so. In a corner of the Chapel, according to the new arrangement, hung the tapestry of the *Conversion of Saul*.

This composition rushes leftwards, towards the altar wall. Saul is knocked off his feet by the swooping apparition of Christ in the sky above. Soldiers and horses rush towards him. Diagonally above this scene was the section of the *Last Judgment* in which the damned souls are dragged down into the infernal depths. And at the far edge, on a trajectory that would carry him zooming into Raphael's picture, Michelangelo had placed a heroically muscular demon wearing a sort of green shower cap, flickering with flames.

Perhaps it was a coincidence, but on the other hand, it was just the kind of joke that Michelangelo would make: simultaneously hinting at what he thought of his dead rival and out-gunning him one more time. The devil had a fiendish vigour that Raphael's suave figures didn't quite equal.

<div align="center">*</div>

Artists are always in dialogue with each other, with predecessors and also with their contemporaries. That's how art works, through an unending process of imitation, rejection, response, quotation, and even, as Lucian Freud pointed out, jokes. Like other kinds of human conversation, these interchanges are not always placid. Powerful egos and divergent talents are involved.

Of course, great artists may collaborate happily with one another, as Picasso and Braque did in the heyday of Cubism. Sometimes they compete, but regard each other with respect and – again – learn from each other. Picasso and Matisse maintained that kind of guarded, but mutually beneficial, anything-you-can-do-I-can-do-better relationship. But Michelangelo and Raphael were bitter rivals. Grudges were nursed, by Michelangelo at any rate, and suspicions harboured.

Raphael, *Conversion of Saul*, c. 1519, Vatican Museums, Vatican City

However, that did not stop Raphael, who was eight years younger, learning plenty from the older master. This in turn drove Michelangelo into a state of simmering paranoia. He thought Raphael was stealing his ideas and trying to pinch his jobs. On both counts, he may well have been right.

On 31 January 1506, he wrote from Rome to his father Lodovico in Florence. Among other things, he wanted Lodovico to move a certain marble Madonna indoors – presumably he had been carving it in the open air – 'and not let anyone see it'. He also wanted a chest, perhaps containing drawings, kept safely away from prying eyes. Whose eyes would those have been?

Very possibly Raphael's. Originally from Urbino, in the years 1504–08 Raphael seems to have spent a good deal of time in Florence. Aged 23, he was already snapping at the heels of the leading masters of the Florentine school, Leonardo da Vinci and Michelangelo. He drew the latter's *David*, learnt from his lost cartoon for a mural of the Battle of Cascina, borrowed and adapted ideas from his Madonnas. Much later, in an irascible moment, Michelangelo exclaimed that everything Raphael knew in art 'he learnt from me'.

The accusation wasn't quite fair. Raphael learnt a lot from Leonardo too, and from his first master, Perugino. Michelangelo's public criticism, made to his assistant Condivi in what was effectively an as-told-to biography published during his lifetime, was more measured: 'All that I have heard him say, is that Raphael did not have this art from nature, but from long study.' In other words, Raphael was an inspired assimilator and homogenizer of other people's styles – 'a brilliant imitator' Condivi calls him – not a true originator.

There was some justice in that. Nonetheless, for some years, he was a dangerous competitor to Michelangelo. Again according to Condivi, relaying Michelangelo's memories – after the first section of the Sistine Ceiling was revealed in 1510 – Raphael made a bid to finish the project himself. In retrospect the suggestion that anyone else should have the job of painting half the ceiling seems fantastic. But Raphael was efficient, charming, courtly, easier to deal with and better looking. And he did very rapidly pick up 'the new and marvellous style' of the ceiling, painting his versions of Michelangelo's prophets

Michelangelo, *The Crucifixion of St Peter*, *c.* 1546–50,
Pauline Chapel, Apostolic Palace, Vatican City

in two Roman churches. He may well have been auditioning in the
hope of getting the ceiling.

He didn't succeed. However, after Julius died in 1513, Raphael had a
virtual monopoly on the favour of his successor, Leo X. One of the sons of
Lorenzo the Magnificent, Leo had been brought up with Michelangelo
in the Medici household. He talked of him, according to Michelangelo's
friend Sebastiano del Piombo, 'almost with tears in his eyes'. But he also
insisted, 'he is terrible, one can do nothing with him'. So when the task
of designing the tapestries was handed out in 1515, it went to Raphael.
For Michelangelo, it must have been a humiliating blow.

<p style="text-align:center">*</p>

As the tapestries went up, one by one, we could consider what the
connoisseurs of the Renaissance most enjoyed: a *paragone* or compari-
son. It was easy to see how hard Raphael had tried to vanquish the
older man. Tried but failed. Raphael effortlessly outshone the earlier

frescoes on the walls above his tapestries, even though these were by famous masters including Botticelli, Perugino and Signorelli. You just didn't notice them. Raphael's figures had more gravitas, more oomph, more presence.

But my eyes went from the tapestries at the bottom to the ceiling high overhead – and very often stayed there. Raphael could not match the thunder of the prophets and sibyls, Adam and God the Father on the vault above. It's hard to imagine that anything could.

*

After hours spent in the tranquil, light-filled chapel it was time for us to go. But, as a final treat, Father Mark agreed to let us into the Pauline Chapel. It took some arranging, since the host was reserved behind the altar, which meant that intruders had to be accompanied by a priest at every moment, and Father Mark had to be elsewhere. Eventually a suitable ecclesiastical minder was found, and we were led through the doors at the eastern end of the Sistine, across the spacious late Renaissance audience chamber, the Sala Regia, and into Pope Paul III's chapel.

It was the completion of a three-part retrospective of Michelangelo the painter that very few, except Vatican insiders, usually experience. On the Sistine ceiling, painted when he was in his thirties, the majestic nudes, sibyls and prophets are filled with youthful strength. Those in the *Last Judgment*, executed in his early sixties, are still immensely energetic, but move more frenetically, some tugged down to their doom.

He was 74 when he completed the *Crucifixion of St Peter*, the second of the two Pauline frescoes (the other, like the Raphael tapestry I'd been musing on, was *The Conversion of Saul*). In both, but especially the *Crucifixion of St Peter*, the figures huddle like survivors on a bleak plain – still mighty, but as if almost crushed.

After that we left, and Waldemar suggested we should go to Santa Maria del Popolo to compare Michelangelo's *Crucifixion of St Peter* and *Conversion of Saul* with Caravaggio's early 17th-century versions. But then the heat hit us again, and we decided instead to find a bar and have a drink. There is a limit to the *paragone* you can digest on a single day.

7 Jenny Holzer and Leonardo's *Lady*

Misunderstanding can be as fertile, creatively, as understanding, perhaps more so. Indeed, art history, and perhaps other kinds of history, is based as much on the former as on the later. Two very prominent contemporary artists have told me how crucial decisions – and in a way their whole lives – were based on getting the wrong end of the stick.

When I met the minimalist sculptor Carl Andre in 2004, he told me about an instant at which he conceived his radically novel way of making art. One day in 1959, Andre was putting the final touches to an abstract sculpture in wood. The work, entitled *Last Ladder*, was carved on only one side. When he had finished, Andre's friend the painter Frank Stella walked in, ran his hand down the smooth reverse side and remarked, 'You know, Carl, that's sculpture too'.

For Andre it was a eureka moment. In a flash, he realized that he did not need to *carve* his sculptures at all. The materials themselves, he suddenly saw, were cutting into space. From then on his sculpture has consisted of materials such as metal plates and firebricks, just as they were delivered from the factory, unaltered by his hand and

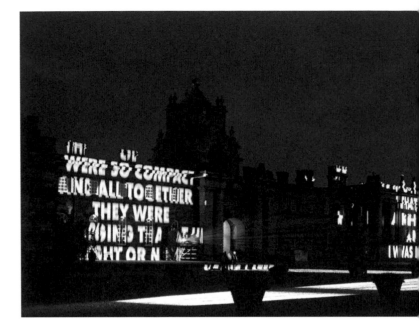

arranged on the floor. Thus began one of the most celebrated careers in contemporary art – or infamous ones, if you are not an admirer of Andre's *Equivalent VIII* (1966), otherwise known as the 'Tate Bricks' and for a while in the 1970s the most vilified piece of avant-gardism in the world.

It was many years later that Andre happened to be at a dinner party at which Stella was also a guest, and began to describe this hugely important moment of creative illumination. Then he noticed that his friend was struggling to contain hysterical laughter. So, a little annoyed, he challenged him: didn't it happen just like this?

'Carl,' Stella replied, 'it happened just the way you describe, but you *still* don't understand. What I meant was sculpture is not like painting: you have to do it on *both* sides.' So, Andre concluded – with satisfaction, when he related all this – his life's work was based on a misapprehension.

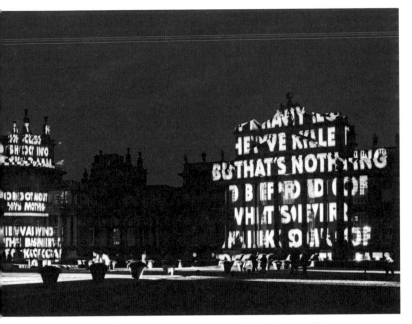

Jenny Holzer, Installation view of *SOFTER*, Blenheim Palace,
Woodstock, Oxfordshire, 2017

The second example contained two artists much more widely sepa-
rated in time. Andre and Stella are friends and contemporaries, working
in similar abstract idioms. It isn't very surprising that one should affect
the other, even by accidentally triggering an idea that, one guesses,
was already lying latent in the other's mind. But who would imagine,
that there was any creative relationship between Jenny Holzer and
Leonardo da Vinci? Yet that is exactly what she revealed had happened.

Leonardo's effect on her, however, was not to do with how her
work was made, nor, directly, how it looked since she is an artist
famous not for painting or draughtsmanship but for working in the
medium of words. These have been emblazoned in neon, carved in
stone, appeared on T-shirts, printed on posters, and inserted in innu-
merable other ways into the everyday world.

Her first major work, *Truisms* (1977–79), which she once pithily
described as 'Jenny Holzer's *Reader's Digest* version of Western and

Eastern thought', consisted of phrases printed on sheets of paper and stuck up around Manhattan. They were a mixture of the clichéd, commonplace, debateable and the troubling: 'BEING HAPPY IS MORE IMPORTANT THAN ANYTHING ELSE'; 'ACTION CAUSES MORE TROUBLE THAN THOUGHT'; 'DEVIANTS ARE SACRIFICED TO INCREASE GROUP SOLIDARITY'; 'LACK OF CHARISMA CAN BE FATAL'; 'MONEY CREATES TASTE'; 'MEN ARE NOT MONOGAMOUS BY NATURE'.

I met Holzer for the first time – face to face that is – on a late summer afternoon in 2017 at Blenheim Palace, where she was planning to disrupt the Baroque architecture of Vanbrugh and Hawksmoor with some piquantly placed words. She liked the megalomaniac dottiness of the exterior, she confided, 'which is somewhere between aggressive and funny and fascinating and illogical'. But she did not intend to let the power of the architecture to 'roll' her. She would insert her words over and against the rhetoric of the masonry.

A surface she worked on, she explained, didn't even need to be solid or stable – in fact it might be good if it wasn't (like the lake at Blenheim). 'I suffer from vertigo, so maybe I like to share it.' Sometimes, she added, 'the text might be projected on a river and the water will do plenty to it – then when a duck or a rat swims through, perfect! A momentarily interrupted word, courtesy of a rat.'

In person, Holzer turned out to be affable, even jolly, and had a quality – one she shared with two otherwise dissimilar artists, David Hockney and Tracey Emin – that charms journalists: almost everything she said was quotable.

*

Although this was the first time we met, it was not the first occasion on which we had spoken. That had been sixteen years before, on a transatlantic telephone line. At the time I was working on the series for the *Daily Telegraph* in which I asked living artists to choose and talk about a work by someone else. When I called her number I had no idea what she had decided to discuss. From the radical nature of her own approach – provocative and implicitly political – it might have been

something by Marcel Duchamp or Andy Warhol. Her actual selection came out of the blue: Leonardo da Vinci's *Lady with an Ermine*.

It had affected her, very early, when she was still a little girl. Holzer was born in 1950 and grew up in Gallipolis, a small town in southeastern Ohio. 'Strangely,' she remembered, 'I thought I was an artist when I was very little. I drew well and naturally, an ability that has since deserted me entirely. I drew the story of Noah's Ark as a scroll of paper. I don't know if it was any good, but it was certainly ambitious.'

However, the only famous artist she knew of was Picasso, of whom she'd seen photographs: 'you know, a short lusty man in a bathing suit at the beach. How could I be that?' So becoming an artist seemed impossible to her, until, that is, one day when she was leafing through a book and came across a 'tiny reproduction' of the Leonardo portrait.

What she told me next was even more surprising: 'This is absurdly personal and irrational, but – well – it can probably tell you the truth. When I looked at the painting, I thought the way a child does, that perhaps the woman in the artwork *was* the artist. And it was partly because she was androgynous and had such an intelligent face and exquisitely sensitive hands.'

That moment changed her life. 'Somehow seeing this image of her as an artist made me think that I could work someday. I wouldn't be so overreaching as to say that it is a self-image, but it is an image to which to aspire.'

When Holzer said all this I was disconcerted. The idea of the series was that artists should provide insight, but this sounded more like the kind of confusion to which the works of Leonardo are prone to give rise. It has been suggested for example that the Mona Lisa is a self-portrait of the artist in drag, or else a depiction of his assistant and presumed lover Salai. A few years after we spoke, an international bestseller was based on the (deluded) claim that the figure of St John in Leonardo's *Last Supper* in fact represented a woman: Mary Magdalene.

Holzer's childhood assumption that the *Lady with an Ermine* had painted her own picture seemed to be just this kind of Da Vinci muddle. But the more I thought about it, the more it seemed to be one of those apparent mistakes – like Carl Andre's understanding the diametric opposite of what Stella had said – that opens fresh possibilities.

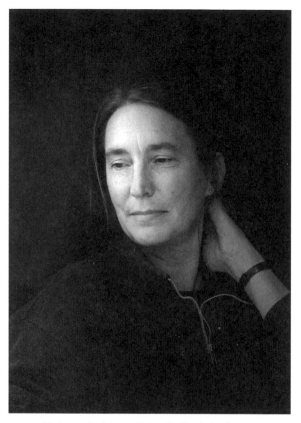

Photograph of Jenny Holzer by Nanda Lanfranco

In other words, it was the kind of misunderstanding that brings about deeper understanding.

For one thing, the androgyny that she noted – and which led to the confusions I've mentioned above – was real. This apparently resulted in her self-identification with the Renaissance master. 'I find Leonardo's very fem *St John* encouraging somehow,' she told me, 'and fascinating.' [She meant the panel painting, not the figure in the *Last Supper*, but that too has caused much fascination.] 'And I think the other picture in the Louvre, of the *Madonna and Child with St Anne*, where St Anne appears to be a man, is wonderful too.' *Lady with an Ermine*, she felt, combines 'mystery, ambiguity – and luminous intelligence'.

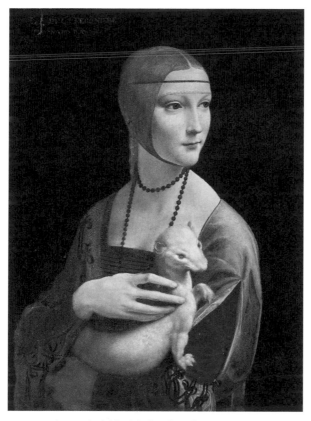

Leonardo da Vinci, *Lady with an Ermine*, 1489–90

Whose qualities were those, though, the sitter's or the artist's? It's a good question, and one I have pondered myself, as a subject for painters. Does Lucian Freud's picture of me, *Man with a Blue Scarf* (2004), for instance, reveal more about him – or about me?

Leonardo had his own views on the subject. He wrote that 'the painter's mind should be like a mirror, which transforms itself into the colour of the thing that it has as its object...', meaning by 'colour' its form and quality. So, if he followed his own advice, when painting the *Lady with an Ermine* he would have made himself into a mirror of her. Perhaps, in some ways, he did. Or, at least, was conscious that was what he might be doing.

Leonardo was well aware of the saying 'Every painter paints himself' ('Ogni dipintore dipinge se'), often repeated in Renaissance Italy and ever since. He mentions it seven times in his notes, sometimes approvingly, sometimes as a tendency to guard against. It could be that the lady has taken on his own dandy-ish refinement and sexual ambivalence.

On the other hand, perhaps the picture owed a good deal to her. As it happens, we not only know who she was, we also know quite a lot about her. The *Lady with an Ermine* is, without any doubt, a portrait of Cecilia Gallerani. At the time it was painted around 1489–90 she was the mistress of the Duke of Milan, Ludovico Sforza ('il Moro').

So, like Leonardo himself, she was a servant, an ornament of the Duke's court, a possession. But also like the great artist, she occupied her position because of remarkable personal qualities. According to a contemporary witness, Cecilia was 'beautiful as a flower'. And she was really intelligent, just as Holzer recognized; later in life Cecilia became a patroness of writers and a poet herself.

Remarkably, there is a surviving letter that gives a hint of what she thought of her picture. After Ludovico's marriage, she ended up owning it herself. In 1498, a decade or so after it was painted, Isabella d'Este – Marchioness of Mantua, and an avid, rather bossy connoisseur of contemporary art – asked if she could borrow the Leonardo, which was clearly already famous, so she could compare it with a portrait she had by Giovanni Bellini.

By that time Cecilia had married an elderly aristocrat, who soon died. She had her own palazzo in Milan, and a notable salon. Cecilia replied to Isabella, agreeing slightly reluctantly to send the picture, her hesitation being that she felt it did not any longer look like her, but this was not due to any failure on the part of the master, 'whom I truly believe to be without equal', but because it was painted when she was so young – 'at an imperfect age' (she was 25 when she wrote this) – that 'if you put the portrait and me side by side, no one would think it was me represented there'.

Perhaps she had changed; perhaps it never was a good likeness. Certainly, Leonardo's two later female portraits, the Mona Lisa and the one known as *La Belle Ferronnière* – the latter may depict another

of Ludovico's mistresses, or perhaps his wife – are highly idealized, or Leonardo-ized. In that sense you could call them self-portraits: they tell you more about his inner landscape than about the sitter.

The *Lady* does not feel like that. More than any other Leonardo portrait – a painted one, at any rate – it transmits the sense of a living personality. A few years after it was painted, a poet at the court of Milan named Bernardo Bellincioni wrote a sonnet about the portrait and its sitter, noting that Leonardo 'by his art he makes her look as if she's listening, and not talking'. That's exactly right.

Cecilia's gaze – cool, appraising, thoughtful – is directed outside the picture, towards someone standing on her left, perhaps the Duke himself. She's attentive, but at the same time controlling the animal she holds. Holzer pointed out that 'her hands are not only beautiful and sensitive but obviously pretty capable, because she's keeping a weasel, or an ermine, captive and happy. They are both very graceful presences.'

The ermine stood for Ludovico himself, because he had been awarded the Order of the Ermine by the King of Naples. And apparently Cecilia did control him, or at least he was undiplomatically reluctant to give her up for his wife (the daughter of the Duke of Ferrara) in 1491. In addition, the weasel – *galé* in classical Greek – was a punning reference to her own surname, Gallerani. So she is both keeping the Duke 'captive and happy', and has herself in hand, the essence of poise.

*

At the time Holzer and I spoke about the Leonardo, neither of us had seen the actual painting. She mused that someday she would get up her courage to 'stand in front of the picture as opposed to just imagining it'.

A few years later I saw it on a visit to Krakow in its room at the Czartoryski Museum, and again in 2011 at the National Gallery in the great exhibition *Leonardo da Vinci: Painter at the Court of Milan*. One evening while it was in London, Josephine and I had an intimate audience with the *Lady*.

Despite enormous pressure to get into the show, the press office had managed to nab and hold onto an evening slot to which journalists were invited with their guests. Trays of drinks were on offer outside the galleries, and – the press being what they are – almost everyone paused to consume a glass of wine or two before tackling room after room of Leonardos. We spotted an opportunity and went straight in. Then for a while we were completely alone in the room where the *Lady* hung, and on another wall, *La Belle Ferronnière.*

Both are marvellous, but in a contest for attention, the *Lady* – or perhaps Cecilia – won. She exerted the greater force-field. It is a painting that can be appreciated in a reproduction far better than, say, a wall-sized mural. Nonetheless, there are nuances – the reflection in her eyes, the softness of her skin – that you can see only when looking at Leonardo's actual brushwork.

The question remained: was that grace and calm, appraising gaze something that Leonardo gave her – in effect, found in himself? Alternatively, were they qualities he observed in this young woman, a teenager who succeeded, despite the limited possibilities of the time and place in which she lived, in becoming independent, a respected writer and intellectual? Or had Jenny Holzer added an extra layer of meaning to this 500-year-old painting, by seeing it effectively as a mirror of herself?

Over tea at Blenheim I asked Holzer whether Leonardo's *Lady*, with its honed elegance, was still an ideal of hers. She answered with delicate precision and a touch of irony. 'An elusive one. Yes – to aspire to on a good day, not littered with problems and regrets. But when there can be grace as well as content – how wonderful!' Leonardo would have agreed.

ART AND LANDSCAPES

8 Roni Horn:
Changeable Weather in Iceland

In 2007, I flew 1,200 miles north, almost to the Arctic Circle, to look at a collection of twenty-four subtly different varieties of water. This is the kind of experience that may sometimes present itself to an art critic. It was not one I had sought out. And, I must confess, though I am familiar with the occasional oddities of the avant-garde, comparing very slightly different samples of H2O, visually, did strike me as distinctly peculiar. But though it sounded odd (many might think water was just water), and it didn't seem likely there would be any perceptible distinctions to be seen, I thought it also sounded rather interesting.

Before I made the journey I had never been to Iceland, the location of the strange work I was travelling to see; neither did I know much about Roni Horn, the American artist who had made it. So this was a learning experience, and therefore one from which I might return – like those minutely dissimilar specimens of water – just a little bit different myself.

The purpose of my journey was the opening of a new installation (I think that's the best description) entitled Library of Water. This was located in Stykkishólmur, a small community in the northwest of

Iceland. It was, the Internet told me, 103 miles south of the Arctic Circle and routinely enjoyed an unusually mild sub-Arctic climate, with summer temperatures of up to 10 degrees Celsius. However, it wasn't yet the short Icelandic summer, more late spring. It was warm in England, but I suspected that just south of the Arctic it would be brisk. I'd had a cold the week before and was still harbouring a nasty cough.

Weather, as it happened, was highly relevant to the objective of this trip. Roni Horn's new piece was, among other things, very much about wind, rain, humidity and temperature. She was obsessed by the subject. I'd had a conversation with her in a London gallery a little while before setting out. 'When you talk about the weather,' she had said, 'you talk about yourself.' Set into the floor of the Library of Water, in both English and Icelandic, was a glossary of words we use to talk about the climatic conditions and the state of the sea and air around us: 'oppressive', for example, 'frisky', 'sunny' and 'nasty', 'bitter, dull, gloomy, bright and atrocious'.

All the ways we talk about the rain and the wind, Horn had explained, we also use to talk about ourselves. She was publishing a book to accompany the Library of Water, the title of which neatly made this point: *Weather Reports You*. And, of course, physiologically, this is based on fact. Many of us suffer from seasonal affective disorder (SAD), our spirits dipping as the light level goes down (which would make the near total darkness of an Icelandic winter hard to take). I certainly feel brighter if the sun is shining, and other things being equal, my spirits are lower if the sky is grey.

The other common factor shared between people and meteorology, especially in Northern latitudes, was *mutability*. Both we and it change all the time. Horn put it like this: 'I definitely am not the same person talking to you as to the next person. There is a difference, and it's caused by how you affect me.'

Fluid ambiguity was part of her persona. Small and slight but strong looking with short, grey hair, Horn was certainly a striking figure. A magazine profile rightly suggested that, 'A quick glance at Horn on the street or in a restaurant would yield few conclusive clues to her gender.' She talked about 'growing up androgynous'. Even her

Photograph of Roni Horn by Mario Sorrenti, 2017

name, she pointed out, is not male or female. 'It seems to me,' she explained, 'retrospectively, that my entire identity formed around this, around not being this or that: a man or a woman.'

The plane from Stansted took me over an astonishingly beautiful North Atlantic, sparkling in the afternoon sun. These were Viking seas, at the edge of the world they explored. As I gazed out of the window, it struck me how remote and isolated Iceland truly was. But my first impression on landing at Reykjavik airport, some distance south of the town itself, was more to do with cost. The taxi fare to my hotel came as a shock.

This was just before the credit crunch began, and the pound was extremely weak against the Icelandic króna. Even allowing for that, the Icelandic cost of living was high. It was Saturday night when I arrived, and, it emerged, locals were in the habit of tanking up at home with a few shots of Vodka before hitting the bars so as to keep down the bill for the evening out.

At the hotel, I met the other writers and critics in the party, including several I already knew well: Alastair Sooke from the *Daily Telegraph*

Roni Horn, *Untitled* (*'A dream dreamt in a dreaming world is not really a dream, ...
but a dream not dreamt is.'*), 2013

and Gordon Burn who was representing the *Guardian*. This was a press
trip, an experience that can be, as it was this time, a bit like a mobile
party; one long animated conversation that lasts for days.

In Reykjavik, we were first taken to the opening of an exhibition of
Horn's work at the Art Museum. The media she used were as changeable
as the rivers, sea and weather with which she was preoccupied. Some
works took the form of photographs, others of texts, still more of semi-
transparent minimalist sculptures like solidified chunks of something
previously fluid. After looking round, we mingled with other guests
at the private view. One was an unassuming middle-aged man with
whom we fell into conversation.

After he had inquired as to what we were doing – answer, jour-
nalists from Britain come to look at an installation made of water
– someone asked him what he did. He answered, modestly, 'I'm the
president of Iceland'.

It is a small place, in terms of population at least. There are only
330,000 people living in the whole country, which is a bit more
than twice as many people as live in my hometown of Cambridge.

At the time, I remember wondering about the large number of crime novels based in Iceland. How could this tiny nation generate enough murders? (But then, of course, the country houses of Agatha Christie's Britain were not so littered with corpses in reality as they were in fiction.)

The next day we set out in a minibus for the opening of the installation, driving north from Reykjavik along the dun coloured coastal plain with high hills to the east, and almost nothing else to be seen; hardly any trees, occasionally some sheep. Inside the bus, it soon turned out that we had a wide range of personal climatic settings.

Gordon Burn was one of those people who are constantly threatened by heat. Perhaps not coincidentally, he was the one member of the party who had visited Iceland before, in the deep dark and cold of winter, when the sun barely rises (he'd enjoyed the cosiness, he told me). Only a few miles out of Reykjavik Gordon complained it was stifling and he could scarcely breath. A window was opened.

I, in contrast, am only at home in sunlight and warmth; draughts and cold feel like a direct danger to my wellbeing. We drove steadily closer and closer to polar regions, passing on one side Snæfellsjökull, the glacier-capped volcano from which the characters in Jules Verne's novel *Journey to the Centre of the Earth* (1864) began their descent. My cough seemed to be getting worse by the hour, particularly after we finally arrived in Stykkishólmur, where the temperature plummeted and the wind was biting.

There was, however, a splendid sky that evening as we made our way to an occasion probably unprecedented in this area of sparsely populated sub-polar coastline: the inauguration of a major work of avant-garde art. Its location was the upper room of an old building, an odd but attractive structure at the highest point in the small town, resembling, as Horn pointed out, a cross between an 'art deco gas station' and a lighthouse.

In fact, it had previously served as the town's library – hence Horn's title. There was also a piquant paradox to the idea of a 'library' of water: water, particularly in two-dozen minutely different qualities, defies description. It can't be catalogued and words can't pin it down. 'It's familiar and yet it's completely unknown', Horn had said, 'I spend

Roni Horn, *Water, Selected, 2003/2007*, Library of Water, Stykkishólmur.
24 glass columns, each holding approximately 200 litres of water
taken from unique glacial sources in Iceland

a lot of time around water, but I never feel I'm getting it.' 'Archiving'
this most universal and ungraspable of elements, she freely admitted,
was a bizarre act.

It was, she had continued, the same with Iceland. She'd been visit-
ing since 1975, when she first arrived as a 19-year-old student. Horn is
the daughter of Eastern European Jewish immigrants; her father had a
pawnshop in Harlem but later moved his family to upstate New York.
Iceland was the first foreign country the young Roni encountered, and
had the lure of otherness: a cloud-swathed outpost inhabited by a scat-
tering of stoical Nordic people very different from Jewish New Yorkers.
For her, Iceland became a sort of huge open-air studio, a place to work
and generate ideas.

In the main room of the old library Horn had installed a series
of twenty-four tall, floor-to-ceiling transparent glass columns full
of water. On the floor, thick rubber mats were inscribed with the
lexicon of weather words. Looking carefully at the water columns
I found, if I peered hard, some looked cloudy and opalescent, some
utterly clear, some yellow, presumably with volcanic sulphur. They

were subtly different. But that wasn't the only unexpected part of the experience.

Horn had enlarged the windows of the room, so that the panorama of sea and mountain outside – beautiful and bleak, extending towards the distant valley where the medieval Laxdæla saga was set – became part of the work. Each pillar gathered a condensed reflection of the horizon – and of the people in the room. So I saw my own distorted image, floating in front of this epic, watery landscape. It was a demonstration of another of Horn's contentions: 'In different places you are not the same person. You engage differently in different places, and different places engage you differently.'

The Library of Water was, like many good pieces of art, essentially simple, but capable of attracting multiple meanings. Not the least of these was a reference to the ominous transformation that is in the mind of anyone who approaches these northern regions nowadays: the disappearing of the ice and warming of the world. Climate change was not the subject of the work, but it is a topic that it ineluctably dramatizes.

Each sample of water came from a particular Icelandic glacier, including the one that Jules Verne described and which we had driven past: Snæfellsjökul. And some of these glaciers were vulnerable. With each passing year they were diminished. They were melting away. Iceland, placed between the warm airflows of the Gulf Stream and cold blasts from the North Pole, is a country whose whole history has been dominated by climate and ecology. The early settlers, Vikings who arrived in the 8th century, rapidly cut down most of the trees on the island, eventually rendering themselves semi-prisoners since it became difficult to construct large ships without wood.

In the 13th century the weather grew colder, and remained that way for centuries, making life a battle for survival in this fragile natural environment. To some extent, it was still like that, although by 2007 Iceland had become rich, in fact the fifth most affluent population on earth. However, the financial weather was about to change: nobody knew it then, but there was an almighty storm on the way.

*

For the occasion of the opening, a party of Horn's supporters and collectors had made the journey, most not – like we journalists – by minibus, but by Lear jet. They had landed at a nearby military airfield. After the opening there was a sub-polar art world dinner, held in a rustic restaurant. The guests were an unusual blend of American squillionaires, Icelanders and a substantial contingent of Brits comprising not only writers but also representatives of Artangel, the enterprising British organization that commissioned the Library. It was a jolly occasion. The following morning, the New Yorkers whizzed back in their jets, and the rest of us returned more slowly down the long road to Reykjavik. En route I reflected on how travel, and art, can change your mind just by altering the view.

My trip to the far north had shifted my perspectives. Roni Horn's preoccupation with the weather, which at first seemed esoteric and eccentric, now struck me as universal. What else were the landscape painters of northern Europe – John Constable, J. M. W. Turner, Claude Monet – all concerned with? Their pictures, too, were all about mutability – the light, clouds, moisture, air and wind in constant flux. That's why Constable said that the sky was the chief organ of sentiment in a painting.

Equally self-evident, it now seemed, was Horn's insistence that the weather is inside us, as well as out. 'Identity', she had pointed out, tends to be thought of as 'a discrete, stable, nameable entity'; but she found it was more like water or Iceland: words didn't quite capture its fluid nature. That, obviously, was true. We all change, all the time. And a slight modification in our environment – a drop in temperature, say, rainfall or air pressure – and planet earth and our lives are in deep trouble.

Perhaps I would not have had these thoughts, though, if I had not made this apparently quixotic journey: a 2,500-mile round trip to look at an array of transparent containers of water. On the whole, I didn't think I would have. The trip had been worth the effort. What's more, with each mile we travelled south my cough was steadily and distinctly improving.

9 Sublime Minimalism in Marfa, Texas

My pilgrimage to Marfa, Texas, began as a conspiracy with two plotters, or possibly a case of *folie à deux*. Tate Modern was to have an exhibition of work by the American minimalist Donald Judd in the spring of 2004. The previous winter, Calum Sutton, then the head of press at the gallery, and I arranged a little trip for ourselves. We would fly 6,000 miles to a remote corner of southern Texas, close to the border with Mexico.

It was there, surrounded by hundreds of miles of nothing much but cactus, desert and mountain, that Judd created one of the most spellbinding arrays of modern art in the world. Marfa is to minimalism what the Church of San Francesco in Arezzo is to admirers of Piero della Francesca, or the Ajanta caves to lovers of Indian painting. It is the perfect specimen; the masterpiece; the place that must be seen.

I had wanted to go there ever since I had read an ecstatic account by the critic Robert Hughes of Judd's culminating work, which admittedly – baldly described – does not sound all that exciting. It consists of one hundred aluminium boxes, arranged in a disused army equipment depot. But Hughes hailed it as sublime, the photograph illustrating his

book looked promising, and the discrepancy between the ingredients and the apparently marvellous result was intriguing.

The urge to see it lay dormant until this opportunity arose. It turned out Calum also wanted to make the trip. I got myself a commission to write about Marfa for a magazine, Calum fixed our itinerary. He was to do the driving (it was not until years later that he mentioned he had, at that point, only had a licence for a fortnight).

On the morning we set out I was simultaneously preoccupied and insouciant. I booked my taxi to Gatwick for a time a little too late, and then, unsurprisingly, was held up in a traffic jam just short of the airport exit on the motorway. When I finally arrived, I met Calum pacing up and down in front of the check-in desk, which he was keeping open by willpower (an early sign of the force of character he was soon to show as a busy and successful head of a worldwide cultural communications company).

A few days before, I had begun sitting to Lucian Freud for a portrait, and my mind was full of what was happening in Lucian's studio in Kensington. For the first hour or so over the Atlantic, I sat on the plane writing notes, fixing my memories before they faded. Then I fell asleep. The next day, after a connecting flight to El Paso and a night in a motel, we encountered an artistic world as idiosyncratic as Lucian's, though very different, and a place that was the opposite of Kensington.

London is full of people, restaurants, bustle. Marfa does not have much of those; the population is a little over 2,000, the grazing land is arid. But the area certainly has plenty of emptiness. You notice it as soon as you get out on the road from El Paso; it is almost like entering another dimension – so huge is the sky, so clear the air that mountains 40 miles away are diamond sharp.

When Judd first came here, in November 1971, these were the commodities he was prospecting for: light and space. Born in 1928, he had pushed his way to the forefront of the fiercely competitive New York art world of the 1960s. First through his art criticism – terse and splenetically dismissive of work he did not approve of – and then through his own art. After his early phase as a painter, this almost invariably took the form of boxes.

These might technically be classified as sculpture; actually they were intended as a step beyond both painting and sculpture. You can look into a Judd box and see a rectangular composition in 3-D something like an abstract by Barnett Newman, or Kazimir Malevich, even a J. M. W. Turner sunset. But Judd's boxes, as freestanding objects, also cut into the world around them like a sculpture.

Soon he was at the head of a budding movement – minimalism – whose name, with the traditional disdain of artists for the labels they are given, Judd didn't like (he preferred to call his works 'specific objects'). He considered his true subject and medium to be space – of which he said that 'it isn't found and then packaged. It is made by thought' (the thought being that of an architect or artist).

In his cramped New York studio, Judd felt that there just wasn't enough room to make spacious art. His first solution was to buy a disused factory in then run-down SoHo, which he set about reconfiguring in his characteristic pared-down manner. But after a while even that didn't seem to provide enough space for Judd, who went searching for more. His son, Flavin – named after Judd's friend and fellow-minimalist Dan Flavin – remembers long expeditions into the South and West, before he finally settled on Marfa.

Calum and I arrived after an uneventful drive of a few hours in which we saw few other vehicles, perhaps in retrospect a blessing given his lack of experience at the wheel and, he confided, a complete lack of sleep the previous night. We settled into the Hotel Paisano, in which James Dean had stayed in 1955 while filming *Giant*, and began to look around Judd's personal empire, systematically. It took a couple of days. In twenty odd years, we soon discovered, he had taken over much of the town.

Once he had started, Judd – funded initially by the Dia Foundation – continued to buy and buy. When he died in 1994, Judd owned nine buildings in Marfa including a former bank, grocery store, an ex-warehouse with a floor space of 24,000 feet, a supermarket, and an entire block that he transformed into a combined living-space, studio and courtyard. In the last decade of his life – by then one of the most revered figures in contemporary art – he was making considerable amounts of money, and he spent it obsessively.

Photograph of Donald Judd by Chris Felver, 1992

For a minimalist, he was an extremely acquisitive man. Collections of all kinds abound in his living spaces: numerous kitchens, for example, each lavishly equipped with every imaginable utensil. He accumulated a library large enough for an educational institution, mounds of Native American jewelry, riding-equipment, art, tools – all manner of beautiful things, costly and inexpensive, that caught his eye. As a cook myself, I was struck by the quantities of simple Mediterranean terracotta piled up on every kitchen shelf; I rather like this kind of ware. But Judd's culinary entertainments, and his taste in music, we learned, caused trouble.

He built a high adobe-brick wall around his compound in town, known as The Block, and inside would entertain his art world friends with bagpipe recitals around campfires. Scottish music was one of Judd's more unexpected interests; photographs show him wearing kilts and brandishing pipes. However, some of the townspeople, the majority of whom are Mexican-American Catholics – hearing the

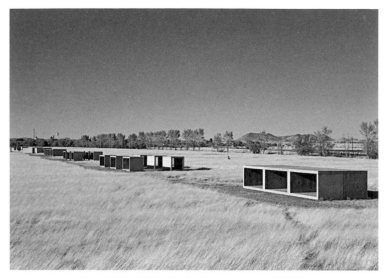

Donald Judd, *15 untitled works in concrete*, 1980–84,
Chinati Foundation, Marfa, Texas

high keening of Highland reels, seeing the flickering flames and the strangely dressed guests from New York – began to suspect the worst. Judd thus became the only minimalist ever accused, even by whispered rumours, of devil worship.

Against this urge to gather clutter, Judd evidently had a counter-vailing desire to arrange things as sparsely and elegantly as possible. The same applied to his working life. He had a series of offices spe-cifically dedicated to every project he was engaged on: each with a superbly orderly Judd-designed desk. So the more things he did and owned, the more places he needed to do and put them in; which was no doubt one reason for his grandest collection – of space.

Calum and I inspected the ex-bank in which his extensive collec-tion of modernist furniture was arrayed, and the former supermarket dedicated to a collection of saddles, reins and stirrups, each arranged on a separate table. Nor did Judd's terrain end at the city limits. In the countryside around he added 34,000 acres of land with three more houses; it was to the most remote of these that he retreated when he really wanted to get away from it all.

Donald Judd, *100 untitled works in mill aluminium*, 1982–86,
Chinati Foundation, Marfa, Texas

Marianne Stockebrand, the director of the Chinati Foundation, founded by Judd to safeguard the works at Marfa in perpetuity, took us on an expedition to see this ranch. This involved three hours of bumping over mountain tracks from Marfa past quivering cottonwood trees. When we got there, we saw a minimalist pergola, house and bathroom with a beautifully simple, sculptural bath in poured concrete, like something one might find in a museum of modern art. This was not so much a style of art as a complete recipe for existence.

By extension into architecture, landscape and furniture-design the box became an entire – and novel – way of living for Judd. He believed in sharing his life with art, so, for example, the bedroom for summer use at The Block in Marfa is one enormous room – originally part of a military store – containing a low, rectangular bed designed by the artist and a number of large Judd sculptures. The dining room is similarly large and punctuated with examples of his work. Essentially, the way Judd defined space was first to empty it of inessentials. Then he articulated it with a few, perfectly placed objects. In this regard, Judd's furniture functions in the same way as his art.

He set up some remarkable private museums here and there around the town. An ex-wool and mohair warehouse, one of the largest structures in Marfa, was filled with twenty-seven sculptures by his friend John Chamberlain, all fashioned from parts of wrecked automobiles. There and then, as I looked at them, I realized that crushed cars could be real sculpture. One looked like the *Winged Victory of Samothrace*, but they were all different: not squashed bonnets and fenders, but form and energy. The greatest eye-opener, however, was Judd's own *magnum opus*.

Just outside town, he acquired US Army Fort D. A. Russell – then surplus to military requirements – together with barracks, warehouses, store buildings. The installation of 100 mill-aluminium box sculptures by him there, in two huge former artillery equipment sheds, might sound a rather dry affair – rank upon rank of rectangular metal sculptures of identical dimensions exhibited in two large, bare warehouses.

The size of each individual component of Judd's minimalist epic is not all that great (41 × 51 × 72 inches), but the ambition of the whole is. And sheer scale was, in Judd's view, the major American contribution to the development of 20th-century art. 'Pollock', he wrote in 1964, 'seems to have been involved in the problem of this scale first. Newman… developed it on his own in 1950. A few others, a little later, realized its importance.'

Among those others, obviously, was Judd himself. In this work, made in the mid-1980s, he worked on the grandest scale, because part of the work – as you understand when you are on the spot – is the landscape and the architecture. On one side the flat dry plain extends for tens of miles to the distant mountains. The light from it flows through the huge rectangular windows, designed by Judd.

That vast terrain – it occurred to me as I stood there – is the reason for the scale of American art. One of the formative experiences of Barnett Newman's life was his visit to the Native American mounds of Ohio, standing in an immense plain. It is in the Southwest that the masterpieces of land art have been created: James Turrell's *Roden Crater* outside Flagstaff, Robert Smithson's *Spiral Jetty* in Utah, Walter De Maria's *Lightning Field* in New Mexico.

Judd's 100 mill-aluminium boxes belong with those mighty and remote works. The rows of metal containers function as space and

light traps. Each is internally different so they form a vast array of differing formal possibilities. One may have a couple of vertical divisions that light and shade transform into a rough equivalent to a Barnett Newman stripe or zip. Or there could be a rectangle within a rectangle, approximating to Malevich's black square. Another type is divided by a diagonal plate within the box, which, in certain lights, forms a misty, indefinite void: a Turner in a box.

That resemblance is no accident. Judd had started out as a painter. His early paintings, many of which we saw in Marfa, are somewhat like other works of American abstraction of the early 1960s. They consist of simple, geometric shapes: a ring, say, or a row of stripes.

But they don't quite come off. In retrospect it is obvious that these paintings yearn to push out into space. Judd's first specific object from 1962 consists of two red boards joined at right angles, like a screen, and linked by a piece of metal bent at 90 degrees. It is very much as if an abstract painting had just been folded to become a sculpture. As time went on, Judd's work evolved into three dimensions: from painting into sculpture.

The space and light in those serried ranks of aluminium boxes are real not fictional. And because the light is always changing, the work itself is different each time you see it. I walked around it for a long, long time, finding an astonishing amount of variation so that on close examination each unit was different, and every one altered as the sun, streaming through the windows, shifted.

In certain strong horizontal lights, the boxes almost seem to dissolve in light, or to become transparent, as if fashioned from perspex or glass. This is a function of their physical nature. The milled-aluminium surface is matte, but reflective. As a result, the boxes form pools of light and deep inky shadows. Under some conditions they seem diaphanous, as their surfaces are completely composed of soft reflections.

Towards sunset, the boxes flush with gold and can be dazzling. Although they are made of unpainted metal, they are capable of a wide range of colour – blacks, whites, greys, soft gold and silvers, the blue of the Texas sky, the ochre of the dry vegetation outside. There is only one word that fits the experience of this extraordinary piece, the one that Robert Hughes chose: sublime.

10 Descent into Anselm Kiefer's Underworld

The output of some painters and sculptors is spread evenly around the world; the works of others are not. You can see pictures by Titian in many collections; but to understand Tintoretto you've really got to go to Venice.

Donald Judd's personal museum at Marfa was like that and well worth the 6,000-mile round trip. I'd never seen anything like it… until that is, a decade later, I went to Barjac in the south of France and visited the studio of Anselm Kiefer. This was Marfa on stilts: more extraordinary, wilder, madder.

As I set off, I felt I knew Kiefer and his art pretty well. He is, of course, widely regarded as one of the most important living artists. I'd seen and reviewed a number of his exhibitions; I'd interviewed the man himself in the neutral space of a London gallery. But none of this prepared me for what was to come. I imagine the rest of the party felt the same. We were a group of Kiefer enthusiasts and writers organized by the Royal Academy of Arts, sitting on a plane heading for Marseille. But none of us had been to Barjac, so none knew quite what we were in for.

After we landed we were minibussed north. Barjac is in a quiet corner of northern Languedoc, near the mountains of the Cevennes, and not much visited by tourists. We had a pleasant French provincial supper, and stayed in a country hotel. The next morning we got into the bus, drove a few miles to the artist's studio on an estate known as La Ribaute – and the surprises began.

When Kiefer came here he took over an old, abandoned, sprawling silk factory, with a stone-built manor at its centre. Around this are grouped barns in which the textiles were once made and beyond lie thirty-five hectares of the scrubland known locally as *maquis*. This is not the Midi as Van Gogh or Cézanne knew it, more an empty quarter. And I suspect Kiefer likes it that way. The emptiness gives him such scope to fill it up.

'Ambitious' and 'prolific' are inadequate words to describe Kiefer's approach to his work. When he arrived at Barjac in 1992, it required 77 lorries to transport his accumulated works from his previous, southern German, headquarters. Eventually, some years later, he shifted his main centre of operations once more from La Ribaute to another vast site: 36,000 square metres of an ex-department store warehouse on the outskirts of Paris. This time 110 pantechnicons were required, which might suggest only a modest increase over more than a decade of work.

However, Kiefer retained La Ribaute as a sort of private museum. You might call it a chamber of curiosities, except that much of it is outdoors and it extends over the area of a sizeable farm. There is so much to see that we spent most of the rest of the day assiduously inspecting it, with a brief pause for a picnic lunch, and still we saw only part of this immense collection. Clearly, in every way, Kiefer is no minimalist; more of a maximalist.

The farmhouse and the barns turned out to be the most conventional parts of the ensemble. After clambering out of the bus, we peered through a high door into a space where some typical Kiefer works – aeroplanes and battleships made of lead – were in production. Then, in company with one of his assistants, we set off into the landscape.

The first thing we came across was a group of massive towers. Multi-storeyed, irregular, ramshackle, these looked at once old and new. These are made of vast concrete boxes moulded from shipping

containers: the medium-sized ones, like those you see on the back of lorries. Kiefer simply piles the casts up, one on top of another, occasionally inserting a bouquet of metal sunflowers into the structure. There was a mood of menacing utilitarianism about them – watchtowers on a frontier perhaps – but also something fantastic: a touch of Don Quixote's windmills, or a Tuscan hill town such as San Gimignano constructed from industrial debris. Not unexpectedly, given the construction methods Kiefer uses, these concrete piles often fall down. All around was strewn the wreckage of similar mini-Babels that had tumbled.

Being curious journalists, of course we immediately stood next to one of these rickety edifices, taking notes and photos on our smartphones. I suppose if the public are ever allowed to visit this astonishing place – as Kiefer plans – they'll have to observe these towers from a safe distance.

They come into a category of contemporary work first defined by the critic David Lister: dangerous art. And even when not actually perilous, Kiefer's art often exudes an ominous, slightly menacing air. We were to experience much more of this before the day was out.

I asked one of his assistants whether Kiefer minded when his towers collapsed. 'Oh no,' she replied, 'Anselm *loves* it when they do that!' Rubble, indeed, is one of his favoured materials. In a glass gallery space nearby, a lead battleship lay, foundered, as it seemed, on a sea of smashed concrete.

Biographically speaking, you could argue that ruins are Kiefer's natural habitat: they were the background to his childhood, just as Flatford Mill and the banks of the Stour were to John Constable's. Kiefer was born on 8 March 1945, precisely two months before VE Day. His arrival in the world therefore corresponded with the beginning of the postwar era; and he grew up among the devastation of saturation bombing. When we'd met in London, a couple of years before, he told me how he had 'played in ruins, it was the only place. A child accepts everything; he doesn't ask if it's good or bad.'

So Kiefer's life began as the Third Reich ended, in heaps of rubble, ground zero. A far better stylistic label for Kiefer than 'neo-expressionist' – which was tried, but doesn't fit – would be 'post-cataclysmic romantic'. In his early days the question he faced was:

The Seven Heavenly Palaces, La Ribaute

'how can anyone be an artist in the tradition of German art and culture after Auschwitz?'

The next section of our tour, after the towers, featured a group of giant glasshouses, strewn across the landscape. In each of these transparent galleries was a work or group of works selected by the artist.

On the sunny day in May when we were there these had their own built-in hazard – heat. They were the warmest spaces in which I have ever contemplated art. Inside, were sculptures made from Kiefer's signature material: lead. In one, the size of a tropical greenhouse at Kew, there was a full-size lead aircraft from which protruded metallic sunflowers. In another, there were lead battleships lurking like so many metallic sharks. Looking at them, I felt as a time traveller from the distant future might when contemplating the archaeological remains of the disastrous 20th century.

Over the years Kiefer has made many sculptures of warships and planes of lead. Lead books are another speciality. Of course, this metal is an extremely unsuitable substance for all three uses: lead boats would sink, lead aeroplanes wouldn't fly, lead pages are hard to turn. So all three have the poignancy of impossible, useless objects. But there is much more to his use of material than that.

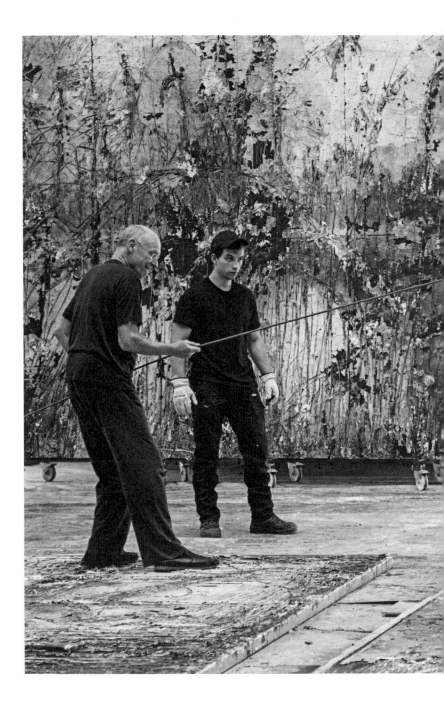

Anselm Kiefer at work

When he talks about these strange objects Kiefer immediately –
and characteristically – begins talking about alchemy. Lead, of course,
was the material from which alchemists hoped to make gold. 'But at
the beginning,' Kiefer explains, 'it wasn't just a materialistic idea, it
was a spiritual one: to transform matter into a higher spiritual state.'
I suggested that in a way all art is alchemy: transforming one substance
– paint and canvas for example – into something else entirely. And of
course Kiefer is a master alchemist in this sense, metamorphosing all
manner of items into a commodity that can be much more valuable
than gold: contemporary art.

After the hothouse galleries, it was time to go underground. The
entrance to Kiefer's subterranean realms lay through a spacious hall –
larger than the biggest rooms at Tate or the Royal Academy – and lined
with huge Kiefer canvases.

He deals with epic subject matter. Often his paintings depict a
landscape simultaneously ancient and modern, covered with ruins
that might be either the result of war damage or the ravages of time:
mighty ruined structures recalling pyramids or ziggurats, halls like
those of Wagnerian heroes, and gloomy funereal vaults derived from
the architecture of the Third Reich. From such pictures, lead model
aircraft and warships may dangle, and metallic wheat or metallic sun-
flowers sprout. The impression is modern and simultaneously reminis-
cent of some lost civilization. One thing I love about Kiefer is that he is
such an enthusiastic exponent of the oil medium; he piles it on so that
exhibitions of new work smell powerfully of the stuff. The paintings
must take years to dry.

He is, despite the range of media in which he makes work, at heart a
painter. 'A photograph', he'd insisted when we talked, 'is only the instant
the shutter was open, while a painting doesn't only show a moment: it
presents a history. It's a living thing. It changes, it has depth.'

His paintings tend to be sober in hue, as if the colours were under a
blanket as of mist. 'I like to hide my colours, if you go close to one of my
paintings, you see all the reds, violets and greens. But I like them to be
hidden under the grey, and I prefer misty landscape because it's more
enigmatic, more veiled.' He admires the German Romantic landscape
painter Caspar David Friedrich: 'the master of fog'.

Amphitheatre at La Ribaute

Kiefer likes things that flow from one state to another. A few years ago, when he had an exhibition in Paris, he had the idea of building a high tower with, on the top, a lead-smelting device that would drop molten metal to the ground, so that 'when the lead arrived at the bottom, it would not be solid but not liquid anymore either, between the two states'. Unfortunately, he was prevented from doing this for 'bureaucratic reasons' – so he did it anyway at Barjac.

*

From this cavernous gallery of his pictures, we walked into a strange and chilling space – part amphitheatre, part courtroom, part prison yard – surrounded by tiers of the same cast concrete from which the towers are made. It felt, as they did, like the relic of some vanished, and possibly malign, culture.

From here we ventured into Kiefer's underworld: a network of tunnels he has built – without the advice of bossy engineers, as he triumphantly pointed out. I suspected that, without our guide, we would have got lost in this labyrinth.

It, too, contained slightly unnerving marvels. One underground chamber was like a hand-crafted version of the ancient Egyptian temple of Karnak: its rough-hewn columns had been formed by digging away the clay from around the foundations of a gallery above. On we went along the passages, occasionally seeing a shaft of daylight above, passing other wonders – among them a lead-lined room, a wall of smooth, yellow, aromatic beeswax by Wolfgang Laib – until we finally popped up in one of the dozens of squash-court-sized galleries – Kiefer calls them 'houses' – with which he has lined the main drive to La Ribaute.

Then, unexpectedly, the master himself joined us. In person, Kiefer at 69 was energetic, jolly – and not much like his work, freighted as it is with the weight of history, intellectual complexity and the horrors of Nazism. He was balding and tanned with a slightly alternative air and didn't seem to take himself or his work too seriously. As we chatted, he remarked that Van Gogh, another artist who moved to the south of France and was obsessed with sunflowers, did all his greatest work in the last two and a half years of his life. 'The achievement is enormous. So there's still hope for me!' He laughed uproariously.

After seeing a few more art-filled houses with Kiefer – who confided that he'd just decided to build yet another – we went back to the main house to have tea. Kiefer originally hails from the Black Forest and it turned out one of his cousins had sent a delicious *Schokoladenkuchen* – chocolate cake – for tea. This was placed on a table in a long room that had once been Kiefer's library.

It was a convivial occasion, but with a slight metaphysical feel. The discussion shifted, predictably in Kiefer's company, from chocolate cake to medieval scholasticism and religion.

You could not, Kiefer remarked, 'imagine anywhere more Catholic than his homeland'. He had been an altar boy, and – he went on – 'you know, I've forgotten a lot of the poems I learnt by heart but I still know the mass in Latin'. Once, he confided, he had studied the Code of Canon Law. 'It's fantastic, I found things you cannot imagine, I found things about condoms for example. You can't use condoms, of course, it's forbidden, but you can if you put a hole in them.' Then he laughed again.

Kiefer was born in Donaueschingen – a little town that is arguably the nodal centre of Europe. There the Danube rises, flowing east to the Black Sea, but a short distance to the west are the banks of the Rhine, on which Kiefer's family later lived. The area he came from is only just in Germany: the border with France and Switzerland is close. As we chatted, I mused that moving south was a natural thing for him to do. Though his art often seems Nordic – not to say Wagnerian – he is not really a northerner.

When he moved to France, however, Kiefer didn't become a French artist – he became a global one. His art took on an international sweep – with references to Mao's China, Jerusalem and the Egyptian pyramids blending into his existing repertoire. Lucian Freud, a very different artist, once said to me apropos his own collection: 'In the end nothing goes with anything. It's your taste that puts things together.' I think that's absolutely right. In a sense, every private selection of valued items – even a *musée imaginaire* is a self-portrait. And so, obviously, is the array of encounters and experiences described in this book. But Kiefer's creation at La Ribaute is more than that. It is a three-dimensional analogue to his mental landscape so spacious that you can wander through it for hours, even for days. I have never been anywhere quite like it.

WAY OUT EAST

11 In Beijing with Gilbert & George

'Beijing', chorused Gilbert & George in perfect unison, 'is now our favourite city!' They were speaking at a banquet thrown to celebrate the opening of their exhibition at the National Art Gallery in the Chinese capital. It was the late summer of 1993. The venue was the Jade Ballroom of the Kempinski Hotel – a spot of such up-to-the-minute smartness that it might have been transported bodily through the air from Dallas. Like everything that happened to Gilbert & George in China, it was pretty well the reverse of what I had expected – amazing in fact – starting with the fact that they, or I, were there at all.

A couple of weeks before, Nigel Reynolds, then arts editor of the *Daily Telegraph*, had rung up and – in an amused tone that signalled he was about to make an extraordinary suggestion – asked, 'Would you like to go to China?' A quarter of a century later, it is difficult to recall quite how distant Beijing – still known as Peking to many English speakers, including, it turned out, *Daily Telegraph* sub-editors – then seemed.

China was high on the lengthy list of places to which it seemed impossible to go. The name conjured up images of massed crowds of bicyclists wearing Mao suits. Nigel and I had grown up to reports about

Invitation card and envelope for the opening of Gilbert & George's
exhibition at the National Art Gallery in Beijing, 1993

the Cultural Revolution; the last Chinese news story that had made much impact had been the Tiananmen Square protests, four years before. In fact, although we on the arts page had not paid much attention, in the early 1990s the economic opening up of China had already been underway for a decade or so. However, the country was far from being the financial and political superpower it is today.

Later, when I met them, it turned out that G&G had also thought of China as distant and forbidding. That in fact was why they had instantly proposed Beijing as the location for the exhibition to follow one they had held in Moscow in 1990. But, George explained, 'I don't think we meant it, really. It was just appealingly outrageous.'

'It seemed like an impossibility', Gilbert put in. So they handed James Birch, the organizer of the Moscow show, a pile of catalogues and said, 'Give them to the Chinese government', thinking that would be the end of it. But the People's Republic came back quickly, saying they'd like to have an exhibition in three months.

To me, at that time, G&G seemed almost as remote and mysterious as China. Although I had been writing as an art critic for some time, there were zones of the avant-garde that were still *terra incognita*. The contemporary art that I championed was the painting that had flourished during the 1980s. With their (allegedly) fused personality – two men, but one artist – their disconcertingly conventional suits resembling those of Thompson and Thomson in *Tintin*, and their belief that they constitute living sculpture, Gilbert & George were inscrutable

to me. But that was about as far as the connection with China went. Otherwise, you might have supposed, Gilbert & George and Beijing scarcely fitted into the same universe.

That of course was why Nigel scented a story. The whole notion was delightfully piquant, even bizarre, which meant what an editor is always looking for: readable. It was obvious from the moment that Nigel opened his mouth that I was bound to say yes to his proposal. Here was an opportunity to step into the unknown – in fact, two different sorts of unknown – but I did so with some trepidation. I had absolutely no idea what it was all going to be like.

My flight out was a long one, involving a change at Frankfurt where the heavy, old-fashioned cassette recorder I was taking to record G&G caused some suspicion at security. All through the night I was woken up at intervals because – a detail that dates this story – I had accepted a seat in the smoking section. A relatively recent non-smoker, I thought it would not make much difference. The result, however, was that periodically smokers came back to have a cigarette, sitting in the empty seat next to mine – and every one of them felt it would be polite to have a conversation while they did so.

In the intervals between chatting and looking out of the window, I read Daniel Farson's book about accompanying G&G to Moscow, an excursion during which heroic quantities of vodka had been consumed. It sounded very jolly, and so did the artists, despite their slightly menacing demeanour. But I was not quite ready to lower my critical guard.

I arrived, tired, at Beijing airport to discover that the Anthony d'Offay Gallery had forgotten to send the promised person to meet me. However, I changed some money, got into a taxi and plunged into the maelstrom of oriental traffic. There were some cyclists in Mao suits still to be seen, but, it turned out, also Mercedes limousines with smoked-glass windows, fast-food outlets and skyscrapers. China was not quite what I had imagined.

*

After a nap, in the evening I went to a reception at the British Embassy, which had – slightly shamefacedly – arranged a party for G&G. This

was not an officially sponsored exhibition, but a private initiative organized by the artists, James Birch, and the d'Offay Gallery. Left to itself the British Council – as George said amusingly and possibly unfairly – might have managed to put on a posthumous exhibition of Henry Moore sculptures, or something 'mouldy' such as that.

No one seemed sure why this Gilbert & George show had been allowed. The diplomatic staff and the BBC representative, Carrie Gracie, pondered what it might betoken. I certainly had no idea. Previously, apparently, no such avant-garde manifestation had been allowed; the closest, an exhibition by South Korean artists a while before, was forcibly taken down. G&G's approach, in contrast, had been accepted with alacrity – and here we all were.

There were various theories to explain why G&G had proved *personae gratae*. One, proposed by a Chinese observer, was that the authorities were still using an out-dated Soviet rulebook, whereby decadent, bourgeois art was expected to be abstract. Perhaps G&G's colourful photo-collages of such things as tongues, manhole covers, plants and themselves passed as a weird new Western form of socialist realism. Their political self-classification at the time – 'normal conservative rebels' – would have baffled most secret policemen. Only the listing I found, in the *China Daily*, sounded a faintly sceptical note. 'These two artists are said to capture a typically British genre of painting. This show is said to help Peking's bid for the 2000 Olympics.'

Socially, the party at the embassy and indeed G&G's whole entourage had an Alice-in-Wonderland quality. A sizable tranche of the European art world had been airlifted in: curators; critics; famous gallery directors such as Rudy Fuchs of the Stedelijk Museum in Amsterdam;, two separate parties of wealthy Italian collectors; the art dealer Anthony d'Offay; sundry friends of the artists; and an engaging Polish expert in Gilbert & George-ology. We met each other from time to time at breakfasts or in the lifts, and waited for the opening.

For some paradoxical reason, connected with keeping the costs down, the *Telegraph* had booked me a return ticket on a flight that didn't leave for a week. So, when not socializing with the G&G support group, I explored, taking taxis to the Forbidden City, Temple of Heaven and other sights around this huge and ever-growing megalopolis. One afternoon I

Gilbert & George, *ATTACKED*, 1991

got lost with a cab driver, fresh from the country, amid the road works for the third orbital motorway (last time I went to Beijing there were five).

Gilbert & George themselves were ubiquitous, wearing special tropical lightweight versions of their trademark suits. Even these less tweedy garments were much too much for temperatures approaching 30 degrees Celsius and high humidity. The rest of us sweltered in shirtsleeves. But somehow – perhaps due to the superhuman self-control that goes with being a living sculpture – never a bead of sweat appeared on either Gilbert or George.

They were seldom to be seen without at least one camera crew in tow (a young American was making a documentary about them), and they were spotted doing their sculpted walk – a slightly slowed down movement that suggests android locomotion – on the Great Wall.

Early one morning I took a taxi to the grander hotel where G&G were staying, to interview them over breakfast. They sat at a table with – unless my memory is playing tricks – an artificial waterfall cascading down the far wall, and I interrogated them, putting, I now realize, rather obvious questions that they had been asked many times before. I felt it was my journalistic duty.

Were they not avid, even unseemly, pursuers of publicity? On the contrary, they responded, there was football in the newspaper every day, but their work was scarcely ever mentioned. 'We think that there

is an enormous hunger out there for art, and most people can never see a Gilbert & George picture', George expounded, 'So the publicity is not for us, it's for the viewer: informing the viewer that there are pictures he can go and see.' Gilbert chimed in: 'Artists are extremely unfamous', and George echoed solemnly: '*Extremely* unfamous.'

Why then, I pursued, did they put themselves in almost every picture? Why constantly draw attention to themselves? George, lighting a cigarette, answered smoothly: 'If you go to the National Gallery and see a Constable, you will say, That's a wonderful Constable. You will never say, I like that grass or I like that tree. You have to know that it's Constable speaking to you. We just took it a stage further from that.'

Gilbert took up the theme: 'What is a Rembrandt? It is himself. All the inner feelings of the artist. Or Van Gogh. It's just him, a completely maniac person. You see his mad vision and that's it. If art is not totally mental, provocative in every way, it's curtains. The end.' George proclaimed: 'I think it's very good we're in the picture reminding the viewer that it's not a boring artwork, only an aesthetic experience. It's us saying something to them.'

This was a way I had never thought about the question before. Modernist critics such as Roger Fry had talked about art in formal, abstract terms. They emphasized 'plastic values' and 'significant form'. Instead, G&G believed in significant *content*, though just what their message was could be hard to determine.

As for those suits, they were a uniform; a way of setting themselves apart as a special sort of person while at same time looking eccentrically conventional, or, as they put it, normal. In the late 1960s and 1970s, when Gilbert & George started out, proclaimed themselves one artist, and defined their idiom as 'living sculpture', those suits looked utterly weird. By the early 1990s, thanks to the revolutions of taste, they seemed almost fashionable.

A few years after the Beijing trip, when I met the sculptor Richard Long, a contemporary of theirs at St Martin's School of Art, he told me about those early days. 'In my first week at St Martin's, George was the chap on the next desk to me. He was a pure, eccentric, fully formed artist/psychopath. It must have been like going to college with Oscar Wilde.'

Photograph of Gilbert & George in Tianamen Square, Beijing,
by Martijn van Nieuwenhuyzen, 1993

Long went on: 'George hasn't changed at all, even the way he looks. When Gilbert arrived in London he was like a shepherd boy from the Dolomites and George took him under his wing.' (Gilbert comes from a community high in the Alps close to the border with Austria who speak neither Italian nor German, but a language of their own, Ladin.)

There really did seem to be some self-identification, on G&G's part, with Oscar Wilde. 'He was a gentleman who dressed up', Gilbert announced, 'and inside suffered totally.' 'Saying that form was all that mattered, and doing the opposite', George added. He continued, 'We only like the *disastrous* artists: Van Gogh, Rembrandt, they all got into trouble.'

Why, I asked, did they put such emphasis on life, rather than art? Gilbert supplied their answer. 'You mean the *vision*. We only believe in that. Even when you see a Michelangelo, it's just his vision, that's the

important thing. Then you find your form. But the important thing is to have a vision.'

As we spoke, even while I was cross-questioning G&G, it was apparent that something else was happening. I found I liked them. They were fun, good company and it was stimulating conversation. In fact, we took to each other. They in turn seemed to like the way I interviewed them. We met in London; I visited their house in Spitalfields and went out for Bacchanalian evenings (particularly during a period when they discovered vintage Champagne was at a bargain price in a local wine bar).

In the way the trip to Beijing was a through-the-looking-glass experience, so was getting to know G&G. As a result I met new people, such as the critic David Sylvester, who in turn, affected my ideas. G&G's contentions, meanwhile, no longer seemed mysterious: more a vivid way of saying something interesting and true. Take the concept of two artists–one man, for example.

From earliest times works of art have been created by more than one person – by Renaissance studios, for example, and married couples. G&G, with their coordinated costumes and simultaneous speeches, were just dramatizing that forgotten fact. Since they did so, art duos and collectives have become commonplace.

It's the same with the conception of 'living sculpture'. The artist's person, life and ideas had long been a subject of art; as Gilbert pointed out, in the case of Rembrandt and Van Gogh the artist's own face was to the fore. Their performances – such as the co-ordinated robotic mime to the old Flanagan and Allen song 'Underneath the Arches' that made them famous, a work entitled *The Singing Sculptures* – were again ways of acting this out, making it clear.

Gilbert insisted that 'Art for us is inventing the morality of tomorrow!' Indeed, over the years, G&G have proved true artist-prophets in several ways. Much of 'the morality of tomorrow' they advocated – greater tolerance of sexual, cultural and racial differences – came to pass in the following quarter century (though not, still, without fierce opposition). Their wild guess that China was the place to go in 1993 seems in retrospect quite obvious.

One point that they had not grasped – none of us had – was that China was already opening up, not just to commerce, but also to Western

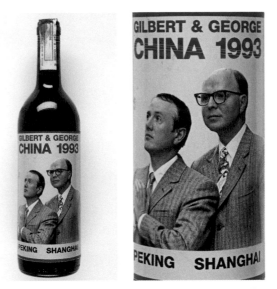

Bottle of Italian wine celebrating Gilbert & George's 1993 trip to China

art. My expectation, and my editor's hope, was that the Chinese public would find G&G incomprehensibly alien. Some of the people I met at the opening did. But I also talked to a couple that compared this show with a G&G exhibition they had seen in London (they didn't think it as good). One man had been very excited to spot the artists in the street, never having thought to see them in Beijing – but, obviously, knew all about them. The globalization of the international art world had already begun, and, like the economic variety, was to gather ever greater pace in the years to come.

Speaking more personally, G&G had had a direct effect on my life: transporting me half way around the world, introducing me to new sights and worlds, rearranging my ideas. It was the first time I had experienced the power of artists to do such things. By chance, I was booked to fly back on the same flight as G&G. At the airport, George noted the arrival time at Heathrow – mid-afternoon – and reflected in his best Lewis Carroll manner, 'Home in time for tea!'

12 Naoshima: A Modernist Treasure Island

The American artist James Turrell once told me that he likes his works to be located in remote places. That way, you have to make an effort to see them, and the time you expend on the journey, he explained, is like a ticket of admission. Having paid it, you look long and hard at the thing you've travelled so far to see. In comparison, he went on, going round a museum is like glancing at the covers of books rather than reading them.

This is a similar idea to that of religious pilgrimage. The journey alone puts you in a particular frame of mind, focuses your concentration. Just being in another place makes you see even similar things differently. Distance in time and space shifts you into an altered state of mind.

I'm still waiting for the right moment to visit Turrell's great project at Roden Crater in the Arizona desert, an extinct volcano that he has been in the process of turning into a mixture of modern art and celestial observatory since the early 1970s. But I did manage to see a group of his works on the island of Naoshima in the Seto Inland Sea of Japan. This place is an extraordinary blend of Tate Modern and Robert Louis

Stevenson's Treasure Island, minus the pirates. But this wasn't a proper pilgrimage, I must admit; more a last-minute change of plan.

We almost didn't go there at all. Josephine and I were in the middle of our first trip to Japan – and I wasn't in the mood for a sudden immersion in the international avant-garde. I wanted to see thoroughly Japanese things such as the Zen gardens of Kyoto and the ancient wooden Buddhist temples of Nara. As a jobbing critic, looking at a lot of contemporary art on the other side of the world struck me as far too much like a busman's holiday.

Josephine disagreed, and she was quite right. We changed our schedule while staying in an updated ryokan, or traditional Japanese inn. This was a modernized and very comfortable version, but nevertheless a place where tight footwear discipline was imposed. We were relieved of our own shoes on arrival, and, as we were shown our room, great emphasis was laid on the importance of wearing the correct slippers at all times. One pair was allocated for walking around the premises and the non-sensitive areas of our bedroom, a second pair – 'toilet slippers' – should be worn inside the threshold of the bathroom. And no slippers were permitted at all if we stepped onto the platform on which the luxurious futon bed was placed.

This was unnerving, and coincided with a particularly difficult phase of our relationship with Japanese restaurants. These had never been easy, partly because of our own failure to master any Japanese at all except a few civilities and greetings. Another factor was the rarity, outside Tokyo, of waiters who spoke or understood English. The consequence was that we fell back on the colour photographs illustrating menus, and the information that can be transmitted in this way is limited if you don't really know what you are looking at.

Our first Japanese lunch turned out, contrary to our expectations, to consist entirely of bean curd sweets. In another restaurant we were misled by a picture of what looked like a delicious oriental version of green tagliatelle. The image didn't disclose that the dish in question was served stone cold. Japan, we discovered, was a looking-glass world. Superficially, it seems like anywhere else in the 21st century. But the more you experience it, the more you find the rules of life are subtly different.

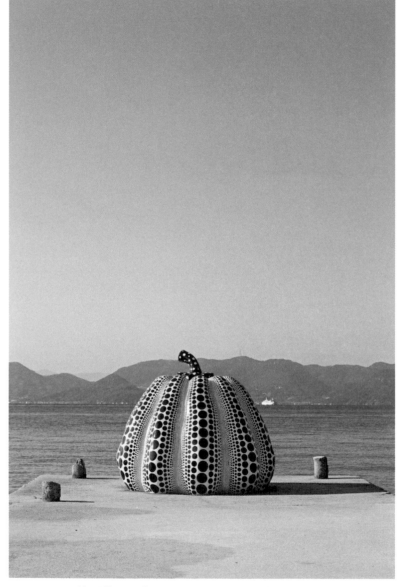

Yayoi Kusama, *Pumpkin*, 1994, Benesse Art Site Naoshima

After a succession of gastronomic shocks or out of toilet-slipper anxiety, we decided to change our itinerary, cancelled our booking in another, more traditional ryokan, and instead headed south to see something more familiar: modern art.

It certainly takes time to get to Naoshima from almost anywhere else in Japan, so Turrell would definitely approve. First you need to go to Okayama, the nearest large town – several hours by bullet train from Tokyo – then you change to a local stopping train that dawdles for another hour or so to the coast, where you have to wait for the ferry. I had the impression that in Japan things are either astonishingly rapid – such as the marvellous Shinkansen high-speed train – or surprisingly lackadaisical, like every local bus and train we took.

But once we got to Naoshima we wanted to stay. Just as Turrell had said, the journey – and the slowing down to contemplation speed – is part of the process. Soichiro Fukutake, the man behind the transformation of this little spot into a modern art lover's Shangri-La, is of the same opinion. Most museums, Mr Fukutake has said, are just places for displaying art. But he believes that: 'The art, the building and the environment should work together to *wake up the viewer*.'

The phrase he used – 'wake up' – recalls the term *satori*, meaning 'awakening, comprehending or understanding', used in Japanese Buddhism. His intention, in other words, is to create a place that is not only a display of first-rate works of art, but also a site that alters consciousness in the way a temple or a shrine might do. And he has succeeded.

Naoshima is a small community with a population of a little over 3,000. At a meeting in 1985, the site was originally imagined by Fukutake's father and the local mayor as a place where children from around the world could gather. The family fortune comes from education, and Benesse Holdings, Inc., in which it still has a stake, owns, among other enterprises, Berlitz Language Schools.

After his father's death, in 1986, Fukutake began to create an art world shrine on Naoshima. Over the years, the project has grown and grown, coming to include ever more works by a multiplicity of artists, and spreading onto the neighbouring islands of Teshima and Inujima. People really do make a pilgrimage to come here. On the ferry I recognized some fellow citizens of the art world. An Italian in an elegant

tweed jacket, for example, was apparently making a round trip from Tokyo – just possible if you catch a very early bullet train, but still requiring a lot of commitment.

We made our visit on a brilliantly sunny spring day, and the first item we encountered after a short trip on a shuttle bus from the ferry terminal was Yayoi Kusama's *Pumpkin* (1994). This eight-foot high, yellow polka-dotted sculpture of a bulbous vegetable is the emblem of Naoshima. That morning *Pumpkin* was silhouetted against a sparkling sea, itself sprinkled with islets shaped like conical puddings. By then the group of pilgrims on the ferry had scattered. We had the place entirely to ourselves. The effect of this colossal gourd was surreal: somewhere between the prize item in a greengrocer's shop and an alien spaceship.

To an eye familiar with western modernism, *Pumpkin* looks very much like a piece of Pop art – which perhaps it is. In the 1960s, Kusama lived in New York and exhibited with Andy Warhol and Claes Oldenburg. But *Pumpkin* is not quite like their cool, ironic works. The polka dots, for example, come from vivid hallucinations Kusama began having at the age of ten. She calls them 'infinity nets'. And we had seen bizarre images of giant vegetables, much older ones, in an exhibition of 18th-century Japanese art in Tokyo. So is *Pumpkin* eastern or western – or an inextricable blend of the two?

The great jazz musician Duke Ellington remarked that east and west were blending into one another, and that everyone was in danger of losing his or her identity (and that was in the early 1970s). Nowhere today is it easier to observe that phenomenon than on Naoshima.

A few hundred yards along the beach we came across a work by the American land artist Walter De Maria. It consisted of two large granite spheres set in a cavity in a small cliff. These were so highly polished that they reflected the opening of this artificial cavern – including the viewer – so sharply that there seemed to be a video screen set into the stone. Here, it seemed to me, was an updated version of Plato's cave; reality mirrored in a perfect geometric solid, embedded within the earth.

This was a clear case of saying a lot with a little. That principle – carried to a logical extreme by the minimalists of De Maria's generation – was at the heart of much 20th-century modernism. But it

Aerial view of the Chichu Art Museum, Naoshima,
designed by Tadao Ando and opened in 2004

struck me as I wandered around Naoshima that it is also very Japanese. There is no greater work of minimalist art than the dry garden in the Zen Buddhist temple of Ryōan-ji, Kyoto. This comprises fifteen rocks of various sizes set in a sea of white, raked gravel; almost nothing, but you could look at it for hours. It was made about 500 years *before* the modernist architect Mies van der Rohe remarked that less is more.

There's not all that much in the Chichu Art Museum, one of four museums on Naoshima. But nonetheless it makes a big impression. 'Chichu' means 'underground', and the building is part cave, burrowed into a hill, part concrete labyrinth. The design, by Tadao Ando, makes it into a work of minimalist art in itself. We walked in via long corridors and courtyards, adorned, like the gardens of Kyoto, with a few carefully positioned stones.

Indeed, we spent a while in Ando's maze of Zen concrete before we encountered any works of art (although doubtless Ando, rightly, would argue that his structure was itself an artistic creation). And when we did see pictures and sculpture, they turned out to be a truly startling combination. The Chichu Art Museum is devoted to three artists: James Turrell, Walter De Maria – and Claude Monet. But no

plodding, conventionally minded curator would ever put this trio
together. Turrell works in the avant-garde medium of light; De Maria
was among the leading figures in the Minimalist movement of the
1960s and 1970s, so they fit together reasonably well. But Monet was,
well, Monet.

When he first heard about the project for the Chichu Museum,
Turrell later told me, his reaction was also 'What?' The link between
the three featured artists – two stars of postwar American art and the
great Impressionist, born a century before Turrell – is in Fukutake's
mind. At first he had fallen in love with, and bought, a twenty-foot
wide Monet of water lilies, then added four more – and eventually
decided to put the two Americans into the mix as well. As I walked
around the museum, I began to understand the connections he had
seen: light, reflections, contemplation.

The five superb Monet water-lily paintings looked, somehow,
more Japanese than the same pictures would in Paris or New York.
Before going into the room in which they are shown, we had to take
off our shoes – as we did when entering a temple – which seemed a bit
extreme in an art gallery. Japanese men, Josephine pointed out, though
otherwise dapper, all have shoes with broken-down heels.

Personally, I don't like shuffling around in my socks under any cir-
cumstances. But once inside the Water Lilies gallery I understood the
point. The floor of this artistic holy of holies is tiled with tiny cubes
of white Carrara marble. Natural illumination filters in from above.
The whole space was ethereally light and pure. Even the attendant –
rather than bored or officious, as such people sometimes are, seemed
immersed in meditation – and so, soon, was I.

What I realized, as I padded from shimmering painting to shim-
mering painting was how oriental Claude Monet really was. After
all, he was a collector and lover of Japanese prints, which hung all
around his dining room, 6,000 miles away in Giverny. And his water
lilies were floating in his imitation Japanese garden. A century before
Duke Ellington made his observation, I realized, Monet's western
identity was already blending with the east. The freedom of his paint
strokes might seem just a flourish of the brush, but when you step
back they become plants, water or reflected sky – very much as I'd

seen in 17th- and 18th-century Japanese paintings in Tokyo and Kyoto by Oriental old masters. 'Modern art' may be a Western invention, but, paradoxically, its roots and inspirations were often far away, in Oceania, Africa, the ancient Americas, and importantly, here in the Far East.

Standing in that room, I had a moment of *satori*. I could see that Monet's subject was everything – growth, change, light, dark, heavens, earth – and nothing (just passing shadows on few feet of pond), which is very Zen. The pictures are about being and nothingness, you might say, or rather – on Naoshima – wellbeing and meditation. Mr Fukutake has said that through the projects on the island, 'I'm searching for eternity.'

We could have spent days on Naoshima – and would have stayed if we could in the island's Benesse House hotel. We had read about how its fortunate guests find original pieces by celebrated artists in their rooms, and can wander into the adjoining museum after closing time. Unfortunately, this paradise for lovers of modern art was fully booked, which did not put me in a state of Buddhist calm. On the contrary, it was downright frustrating.

A month or two after we got back from Japan, I ran into James Turrell again in the very different surroundings of Houghton Hall in Norfolk where he was staging an exhibition. I told him that we had been to Naoshima and he replied that this was the location of one of his favourites among his own works. It is called *Back Side of the Moon* (1999). To see it, visitors (or should I say pilgrims) are led into what at first appears to be total darkness. After about ten minutes it seems an immensely dim, blue or purple oblong of light – a sort of ghostly Rothko – becomes perceptible and then slowly intensifies. It is, like much on Naoshima, an experience that demands time. More in fact than we had had.

Unfortunately, and predictably, this was one of the sights on Naoshima we hadn't managed to see. After three museums and sundry other works set in the landscape, and with nowhere to stay, we'd had to rush for the ferry back to the mainland. Even a Zen art pilgrimage requires more efficient planning than we had managed. But of course efficiency is a very Japanese quality too, and one we clearly had yet to master.

13 Travelling in Chinese Mountains

Suddenly, a small rent appeared in the thick, overlaying cloud. The freezing mist, which had been covering everything since breakfast time, started to ebb away and an extraordinary landscape came into view. It was like looking down on a rocky coast with high promontories, jagged cliffs and isolated islands – except that there was no water.

Instead, this ocean consisted of vapour, revealing or covering at every instant some new aspect of the scene, surging and billowing like slow motion waves. As I watched, pinnacles of granite emerged from the cloud while huge bastions of stone, shaggy with conifer forest, simply vanished.

At last it was time to go; the cable car was waiting.

As I was walking away, the guide tapped me on the shoulder, and motioned at the prospect. With icy fingers I pulled my camera out of its case again, and raised it to my eye. But, 'Ah', he said, 'You missed best view.'

Nonetheless, I was content. I had seen – if only for a few minutes – the Sea of Mist from the peaks of Huang Shan, the Yellow Mountain range. In its way, this is a sight as fundamental to Chinese culture as

the Pantheon is to the Greek, or the Pyramids to the Egyptian. In a way, it is *the* subject of Chinese art.

It was the late autumn of 2003. I was at the end of a lengthy trip around the mountains and mountain-sanctuaries of China. The journey had been fascinating, and surprisingly gruelling. Generally speaking, the life of an art critic cannot be described as adventurous, but this expedition had required, at least, stamina and hardihood.

My companions were a group of French curators and journalists, plus a British friend and colleague, Michael Glover of the *Independent*. I was delighted to be invited for the itinerary looked beguiling – and indeed proved memorable. Here was an opportunity to visit distant corners of the country and see ancient temples and monasteries.

However, what the schedule had not indicated was the cold, or the snow. The thermometer was dropping when we arrived in Beijing, and by the time we pulled out of the city in a sleeper train bound for the northeastern peaks Wutai Shan, a blizzard was blowing. Horizontal streaks of snow whipped across the carriage windows. The man from *Le Figaro* handed round whisky from a flask, which was welcome.

He used the arm that wasn't in a sling, because he was the first casualty of the expedition. An old China-hand, he had elected to cycle around Beijing while the rest of us visited cultural monuments during the day before we caught the night train. He had ended up being taken to hospital with a broken wrist.

We arrived at dawn, after a few hours fitful sleep, in a winter-wonderland with a foot or so of snow on the ground, climbed into a coach and ascended the heights of Wutai Shan. This area is one of the four canonical sacred Buddhist Mountains of China, and it is the most venerable of the quartet: the first to be revered. We were staying in a hotel in a valley surrounded by five high peaks (Wutai Shan rises to 3,000 metres).

All around and above us were ancient monasteries. It was astonishingly beautiful; an Oriental landscape that might have been painted by Monet in his snowscape mode. It was also, obviously, freezing. This place was long ago identified as the abode of the bodhisattva Mañjuśrī, one of the most important figures in Mahāyāna Buddhism. In a

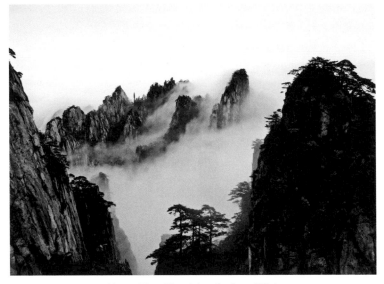

Huang Shan Mountains, the Sea of Mist

venerable text, the 2,000-year-old Avatamsaka Sutra, he was said to dwell on a 'clear, cold mountain'.

Wutai Shan certainly fitted both of those descriptions during our visit. This was in one way a blessing. At warmer times of year, I gathered, tour buses full of visitors would descend on this place, remote though it was. But at that season we were more or less the only people there. It was glorious, though it soon emerged that there were certain hazards to this jaunt.

Dinner on our first night at Wutai Shan consisted mainly of a slightly grisly cauldron of Mongolian hotpot, featuring a quantity of bones. The next morning, one of the curators accompanying the group did not come out of his room; it was another twenty-four hours before he reappeared, pallid and shaky. On the plane from Paris I had read the health and safety section of my guidebook, with the result that I was already inclined to caution when selecting food from the lazy Susan on which a variety of plates were usually on offer at mealtimes.

This incident restricted me to a diet consisting largely of boiled rice and steamed vegetables. Also, it became more and more difficult to

Xian Tiong Temple, Mount Wutai

establish exactly what dishes were on offer. We were accompanied by a rather jolly middle-aged man, who described himself as a professor of French literature at Beijing University, though the correspondent from *Le Figaro* privately insisted that he was definitely a secret policeman.

Whatever his profession, it became apparent that the further we travelled into rural backwaters, the more trouble he had in understanding what was said. One day when I was sitting next to him, an appetizing plateful of vegetables arrived together with a white protein of some kind. I asked what it was, and after interrogating the waiter, he said it was chicken. I put some on my plate. But he seemed unsure about his first answer to my question, and after another conversation with the staff, he changed the verdict to frog. Then after yet another conference, finally settled on 'a kind of snail that lives in Chinese rivers'.

I did not touch it, having also read a passage about the toxins and microorganisms to be found in Chinese waterways. Michael Glover overheard a group of our French companions commenting sadly on the lack of gastronomic *joie de vivre* to be observed among Anglo-Saxons. Perhaps they were correct. I was beginning to lose weight.

From the heights of Wutai Shan we drove down by coach, stopping at intervals to see magnificent things, among them Nanchan Temple, built during the Tang Dynasty in the year 782, the most ancient wooden building surviving in China. We crossed the valley of the Yellow River, before flying to Shanghai.

There, in the excellent Shanghai Museum, for the first time in my life I saw a large collection of classic Chinese painting. These were pictures I had often read about, and indeed talked about. The sculptor Anish Kapoor cited them as one of his sources of inspiration; the poet Kathleen Raine suggested that the Chinese masters of the Song Dynasty were perhaps the greatest landscape painters of all – a judgment that I feel may well be correct. But these paintings are hard to see. The best collections are in Taiwan and Kansas City, both places I have yet to visit.

Chinese thinkers believed – rather before Albert Einstein – that matter and energy were one. While reading, jet-lagged in various hotels, I had learned about this belief. Everything was a manifestation of divine energy or qi (pronounced chee). Literally, the word means air, water or breath: a life-force powering the cosmos.

I could see it manifesting itself in every brushstroke in a masterly Chinese painting, of which there were many to look at here. Qi was visible in each sharply pointed bamboo leaf and segmented length of stalk in a medieval handscroll. Every stroke of the brush quivered with energy. But even the rocks around which they sprouted had their own heavier, mineral pulse, created by slashing, sideways strokes.

Chinese painting is often monochrome, the whole range of form and texture being produced by differing qualities of ink and application of the brush. Just as the Inuit are said to have fifty different words for snow, Chinese commentators on art distinguished a whole thesaurus of ink marks. One writer on art in the Ming Dynasty classified no fewer than twenty-six different ways to paint rocks, and twenty-seven means of evoking leaves on trees, among them dry strokes, wet strokes, and the so-called axe-head stroke made with the side of the brush. Such vocabulary, incidentally, is sadly lacking in European languages, which is one reason why it is so hard to discuss painting with precision.

According to an ancient text by a Confucian scholar named Xunzi, born about 310 BC, there was a hierarchy of qi. Such elements

Dài Jìn, *Dense Green Covering
the Spring Mountains*, 1449

as fire and water had *qi*, but not life. Plants had *qi* and life, but not understanding; animals and birds have all three, but not 'propriety', or a moral sense of how to behave and shape the world. Only human beings have that.

In a painting entitled *Dense Green Covering the Spring Mountains* – attributed to an artist named Dài Jìn and dated 1449 – the landscape is swathed in banks of mist that seem to rise from the valleys below. A literary man, using a stick, and his servant are walking through gnarled pines. The artist has managed to express precisely the way the

trees grow, their spiky needles and gnarled bark. The two little figures seem to be climbing towards the upper slopes – much as we, late that evening, were scheduled to fly to Huang Shan.

The Chinese phrase for pilgrimage means literally 'paying one's respect to mountains'. A ruler of the 5th century BC was noted, I discovered, for travelling every five years to the four mountains on the boundaries of his kingdom, making a sacrifice on every one. In Chinese thought, everything merges – rather as it does in misty lakes and mountains. Reverence for high places in early religious belief shaded into a similar attitude in Taoism, and later still in the Chinese version of Buddhism.

The common factor was the possibility of obtaining a sublime experience on mountain tops, which is, after all, not an idea restricted to the Far East. Moses came down from Mount Sinai with the tablets of divine law. In the Romantic era Europeans climbed the Alps and felt closer to God. The ancient Chinese believed that certain sages, the immortals, dwelt in the sacred mountains, living to great ages – up to 800 years – owing to their proximity to heaven.

They also felt that there one could see the world in a process of constant becoming (just as, on a smaller scale, you could in a blade of grass or bamboo leaf). In the mountains, as one contemporary described a landscape by the 12th-century painter Li Gongnian, you could watch 'shapes of objects appearing and disappearing in vast emptiness'. It was a process of endless flux, an interaction of opposites: in Chinese thought this comes from the interaction of yin and yang, that is 'dark-bright', 'negative-positive', 'female-male', 'passive-active'.

But these are not warring forces like good and evil in the Middle Eastern Manichean – and Christian – view of the world, but complementary forces. The sinologist Rolf Stein translated them as 'shady side (of a mountain)' and 'sunny side (of a mountain)'. They were necessary to each other; without a sunny side there would be no shady side, and vice versa. Jointly, their interplay resulted in endless flux: a world in which the person was always adjusting to a new set of circumstances – just like the viewer in these paintings.

I had talked the year before with Henri Cartier-Bresson, who had emphasized how intuition was all, an idea he had gathered in part from

a book about the Zen art of archery. 'Intuition needs sensitivity, and sensitivity involves sensuality', he had said. 'This poses a big question concerning our Western conception of the world and civilization.'

In the years after my trip, David Hockney was to tell me a great deal about his own Chinese journey, undertaken some twenty years before, in the early 1980s, and his subsequent discovery of the Chinese sense of space. This was, he argued, quite distinct from the European, post-Renaissance system of fixed-point perspective, which automatically also fixed the spectator in a certain spot in relation to the world. Whereas, in a Chinese painting, you wandered freely – like the travellers in the mountains – perhaps through a scroll many yards long. There was, Hockney held, no single correct way of representing space, but the Chinese approach had many advantages. The viewer navigated, as we do in the real world, through ever-shifting surroundings using our senses and our intuition.

*

After the group left the museum in Shanghai we had a long dinner, then climbed on a coach for the airport. En route one strapping young French critic was taken so violently ill – presumably as a result of eating something from the lazy Susan at the restaurant we had just left – that paramedics were summoned when we arrived. He lay for a while on a stretcher, having injections, before being half-carried onto the plane with the rest of us. We arrived very late at a hotel at the foot of the Huang Shan mountain range, and the next morning took a cable car up to the heights.

When we checked in at our accommodation at the top it turned out that the luggage had been left accidentally at the bottom. Except, as it happened, mine, because neurotically I had refused to be parted from my suitcase and was thus the only one in the party to retain a sponge bag or a change of clothes.

It was quiet up there at the top among the peaks. At the height of the summer season, 150,000 visitors a day shuffled around these paths, and rush-hour Tube-carriage conditions obtained at the point from which each obligatory sublime prospect can be seen. A large

poster outside the hotel showed Deng Xiaoping – the man who suc-
ceeded Mao and began the modernization of China – wearing shorts
and hiking boots and ready to begin the climb. He was only one of
many Communist dignitaries to have made the pilgrimage.

The hotel itself was almost empty and very cold. The heating
was only turned on for a few hours, beginning late in the evening. I
remember sitting in the lobby, dressed in overcoat, scarf and gloves
and sipping whisky – the signature drink of the trip – while a heroic
Chinese woman in a cocktail dress played the piano. We appealed to
our minder to ask the hotel manager to increase the temperature. But,
whether or not he was a secret policeman, it was beyond his powers.
It was, the manager insisted, the hotel's contribution to eco-friendly
energy saving.

It had been, however, worth braving these rigours, a contemporary
equivalent perhaps to the discomforts the travellers in the old land-
scapes would have suffered as they strode up spiraling paths, staff in
hand. Walking the winding paths was like entering into one of those
paintings: a great mass of towering crag came into being and vanished
before my eyes, disappearing into the void.

This was a demonstration that the pictures were more naturalistic
than one might have imagined. The sights they depicted really existed.
But of course, on a deeper level, the point was why this kind of sight
meant so much to the Chinese. To them, it seemed to be a direct expe-
rience of the universe at work. The landscape came and went just as
all things do: people, dynasties, empires, even mountains. Only the
swirling energy is immortal. As a view of the cosmos, it is astonishingly
up to date.

SLOW AND FAST
LOOKING

14 Henri Cartier-Bresson: It's the Intensity that Counts

My meeting with the photographer Henri Cartier-Bresson started badly. Things began to go awry the day before I actually met him when I caught a Eurostar from London. Shortly after the train set out, I realized that I had forgotten the address of the flat in which I was supposed to stay, usually occupied by the foreign correspondent of the newspaper for which I was interviewing the great man. I had left the crucial piece of paper on my desk. No matter, I thought, I would telephone my wife later and ask her to read it out.

My head was full of Cartier-Bresson's photographs: a French family picnicking on the banks of the river Marne; a little girl in Rome in 1959 running through the single small square of light cast on the cobbles of a piazza like the angel of the annunciation; Jean-Paul Sartre smoking his pipe on a bridge in 1946, an image that seems saturated with the atmosphere of postwar Paris. I thought hard about how I could persuade this famously prickly man to speak freely about his art.

Five minutes after my train entered the tunnel under the Channel it stopped, and remained stationary for an interminable amount of time. It was five hours late by the time we reached Paris. My wife

couldn't find the address; predictably my attempts to locate the place from a vague memory of the street number failed, and I finally checked into a hotel in the small hours. I was still feeling discombobulated when I rang Cartier-Bresson's bell at ten o'clock the following morning.

His wife, Martine Franck – another distinguished photographer – let me in. I was introduced to Cartier-Bresson himself, who was then an extremely lively 93-year-old. We sat down in the window, with the geometric order of the Tuileries Gardens laid out below. I took out my tape recorder to record the interview, at which point he picked up his walking stick as if it were a rifle, and pretended to shoot the gadget.

Cartier-Bresson did not, it turned out, approve of being interrogated, and certainly not of having his words captured by a mechanical device. 'I like conversations,' he announced, 'I don't like interviews. To the best questions there is no answer.'

I should have been prepared for the unexpected. Henri Cartier-Bresson had not become one of the very greatest photographers who ever lived by doing the obvious. His photographs were a sequence of moments so piquantly perfect in their formal order and revelation of the inner life of people and nature that it was hard to believe that they actually occurred. But apparently they had, every one of them, because Cartier-Bresson's self-imposed principles forbade any manipulation of the image after the split second when the shutter clicked. To capture such fleeting instants required an astonishing degree of absorption in the world as it unfolded around him – and an extraordinary degree of spontaneity.

A trifle desperately, I fished out a notebook and pen from my bag and tried to plough on. Cartier-Bresson, as I was well aware, had a reputation for cantankerousness. For example, famously he disliked having his own photograph taken – and had even been known to threaten those who tried to do so with that stick. I hadn't previously heard about his objection to being recorded, but had come across similar phobias in other people.

At first, I attempted to carry on asking about the topics I had prepared, and the resulting interchanges were distinctly sticky. A typical response, scrawled in my notebook, was 'Answer yourself! Are you my father confessor?' To my first inquiry about photography, the theme of what was supposed to be a lengthy newspaper piece, he brusquely

Henri Cartier-Bresson, *Alpes de Haute-Provence, near Cereste, France*, 1999

replied that he didn't take photographs, and hadn't for years (which was not, as I well knew, entirely true; see image above).

Cartier-Bresson insisted he hadn't even thought about photography for two decades. What did he think about? Anarchism, he replied, and would I like a whisky. Feebly, since it was only a little past eleven o'clock in the morning, I declined the whisky, but eventually accepted a further suggestion of red wine. At this point, inwardly panicking, I changed tack and started to do things his way.

We just began to chat, and from then on the atmosphere steadily thawed. First, he told me his feelings about the English. 'For me,' he began, 'England is the most exotic place in the world. The British manners, the stratification of society: you can see it even in people's shoes. You British never had a revolution, or rather, you had it too soon.' Anglo-Saxons, he complained, found anarchism hard to understand. It was not, as they thought, disorder, but an *ethic*. 'It's more a Latin thing', he explained. He himself was an anarchist, but nonetheless found the exotically irrational world of London 'incomprehensible'.

He felt this, Cartier-Bresson added, even though he had had an English nanny, from Wolverhampton, recalling that there were many

English nannies in France at that time, a generation of girls whose fiancés had been killed in the First World War.

That war, Cartier-Bresson insisted – no doubt in common with everyone who lived through it – was 'perhaps the most horrible thing that has ever happened'. That was why, he remembered, everyone had been relieved when the Russian Revolution had occurred in 1917. Cartier-Bresson was nine at that time; the following year he and his family fled from Paris to Brittany to escape the shells of Big Bertha, the mighty German howitzer that bombarded the city from seventy-five miles away.

At this point I played my only card. We had a friend in common: the painter Lucian Freud. A few years before, Cartier-Bresson – then a mere 89 – had climbed the five storeys to Lucian's top-floor studio in Holland Park, knocked unannounced on the door and taken the painter's photograph (this was one of the reasons why I knew his claim not to have used his camera for years was an exaggeration).

Building on this success, I took a risk and told him a little story that I felt encapsulated a difference between the Gallic and Britannic mind-set. It concerned the history of bridge building in the early 19th century. Apparently, at that period French engineers began to design structures according to mathematical calculations of the stresses and weights involved; but the British for the time being stuck to the traditional method of guessing. Ultimately, the French were following the correct course but in the short term – because the mathematical models weren't quite ready to do the job – more bridges fell down on their side of the Channel.

Cartier-Bresson, fortunately, enjoyed this anecdote, and in some ways took the British point of view. Suddenly he was telling me his philosophy of photography, which turned out to have a great deal to do with instinct. 'There's only one thing,' he began, 'the glance.' For this, he explained, 'You have to walk'. Cartier-Bresson loved to walk. At a certain moment, perhaps suddenly, unexpectedly, the subject, his prey, appeared, and in a fraction of a second, he pounced.

'It's a joy. It's an orgasm. You guess and you're sure. It's intuition and sensitivity – and you can't teach those things. Happily you can teach everything except sensitivity and sensuality.' Can you imagine, he asked me, a Professor of Sensitivity at the Sorbonne?

After the Second World War – which Cartier-Bresson spent partly in a German POW camp, partly in the Resistance – the painter Georges Braque had given him a copy of a book entitled *Zen and the Art of Archery* (1948) by Eugen Herrigel. It recounted the secret of shooting without consciously trying – so the bowstring, in a sense, seems to release itself. In this mystical approach to a sport Cartier-Bresson found a perfect metaphor for photography as he pursued it. Similarly, the photographer waits, camera at the ready, until the moment reveals itself, at which point almost without a conscious decision, the shutter is clicked. Or that, at any rate, was the theory.

'Thinking is dangerous,' he told me, in a spirit a Zen master would approve, 'I like the way a cat thinks.' I remembered that Cartier-Bresson, who had trained as a painter, came of age at the height of Surrealist Paris between the wars. He went to the Surrealist meetings at Place Blanche, but – young as he was – sat at the end of the table and didn't speak. Surrealism, he told me, was concerned with literature and art, but also a way of life. It was not hard to see how the Surrealists' fascination with the unconscious mind and automatic actions might have intrigued the young Cartier-Bresson. 'Losing self-consciousness is one aspect of surrealism', he told me approvingly, it is 'going beyond yourself'. It was the same in archery and photography.

Here I recognized his celebrated theory of the 'decisive moment'. This phrase, a quotation from a 17th-century Cardinal who believed that 'everything in life has its decisive moment', was the title of a book Cartier-Bresson published in the early 1950s. In the case of photography, the decisive moment was that fraction of a second in which the photographer sees the kaleidoscope of life suddenly take on an expressive form. Then the shutter must click; if you miss it, it's gone forever. Or, as he said to me, 'How can you say, "Please could you do that smile again?"'

The composition, with its interlocking angles and shapes, was as important as that smile. But Cartier-Bresson had an extremely sensual – I am tempted to say very French – feeling for geometry. 'Mathematics is poetry,' he told me, 'you don't need to understand it, you just need to feel it and to live accordingly. For me it's the rhythm of shapes. That is a great joy, like when we make love. It comes to the same thing.'

Henri Cartier-Bresson, *Rome, Italy*, 1959

In his view, the photographer had to have that completely internalized, so it was recognized without thinking. The geometric structure was, he insisted, 'sacred'. 'Otherwise it's nothing!' And he raised his fist and forearm in a vigorously obscene gesture.

By this time, all pretence at conducting a formal interview had long vanished, and, of course – paradoxically – Cartier-Bresson was saying fascinating and revealing things.

Of all the remarks he made that day, one above all has stayed with me, seeming to encapsulate his philosophy of art and life. The subject of longevity came up, and he reflected: 'It's not years, months, hours and minutes, it's *intensity* that counts.'

An interview has a certain amount in common with photography, at least as Cartier-Bresson practised it. It is an encounter with another person, often a stranger before the moment you meet. You are allowed by the rules of this game to talk about much deeper, more interesting matters than is usually possible in a social meeting.

But the interviewer must be like Cartier-Bresson's photographer: waiting, poised, until the subject reveals him- or herself. You have to say interesting things, but know when to shut up, because the point is not what you say but what the other person does. In other words, it requires a mixture of intuitive understanding and spontaneity. You have to relax and concentrate at the same time.

By the end of the morning the mood had become so friendly that, as the interview drew to an end, he decided to give me a present: a catalogue of the drawings that he had spent an increasing amount of his time doing as he grew older. As a young man, he had trained as a painter under André Lhote, a teacher who had been, paradoxically, an academic Cubist ('He gave vital training for the eye but he had no imagination').

Now, in his seventies and eighties, Cartier-Bresson had returned to the art he had studied as a young man. As a draughtsman he spoke as if he was still learning: 'It's a matter of structure and your sense of the form. With bosoms it's not so hard,' he confided, 'but when it comes to hands and feet it's a different matter!'

Nonetheless, drawing was an activity in which he was as interested as he was in photography. The latter, he reflected, 'is instant drawing!'

Then, in his anarchic way, having laid down a rule, he instantly over-turned it: 'That's only one aspect of photography – you can do anything you like with a camera – also with a pencil.'

'Do you make little sketches?', he asked me. 'It's essential. I think it's the only way of understanding. Videos should be forbidden. All those gadgets distract people when they should be looking!' This apparently did not apply to the camera he had carried for so many years.

Evidently, however, Cartier-Bresson had slight misgivings about the graphic works on which he now spent so much of his time. He signed the book in the front. But before he did so, he leafed through the pages, and an extraordinary thing happened. He took out a pencil and started to touch up the reproductions, strengthening a contour here and there. By the time he'd finished, he'd amended almost every image in the book. When it came to these drawings, there was evidently no 'decisive moment', no guessing and knowing. On the contrary, he couldn't leave them alone.

By this point it was almost time for lunch, and Cartier-Bresson and Martine Franck hospitably pressed me to stay and eat with them. But still unnerved by my experience with Eurostar the previous day, I insisted on rushing off to the Gard du Nord as quickly as possible to begin the process of going home.

As I was leaving, Cartier-Bresson instructed me not to use the lift, but to walk down the stairs, because in the 19th century in the flat beneath his had lived Victor Choquet, a celebrated art collector. Consequently, the banister had been held long ago by Édouard Manet and Paul Cézanne. I did as he suggested, thinking not only that those famous painters had touched this piece of wood, but so too had Henri Cartier-Bresson.

There was a coda to our meeting. After the interview appeared, a week or two later, I received an e-mail from Cartier-Bresson. While he was on the subjects of geometry and anarchism, he had strayed onto the subject of accountancy. 'We're living in a world of accountants', he had declared, making his favourite rude gesture and proclaiming, 'Mathematics is poetry, accountancy is a prostitution of the subject.' Then, as an aside, he'd added, 'I have a very good friend who is my accountant and is coming to see me tomorrow.'

Not thinking too hard about it, or rather thinking that there was something slightly piquant about this great anarchist meeting his accountant, I had printed the whole quotation. Cartier-Bresson protested that the final remark had been private and should not have been included. I apologized, and we ended the exchange on amicable terms, but I never saw him again.

Three years later he died, just short of his ninety-sixth birthday. I regretted that I had annoyed him by including that fairly harmless remark. But I felt much, much more sorry – in fact, still feel foolish – for not having stayed for that lunch. My mistake lay in sticking to the plan – not following where life led, spontaneously.

Several remarks he made that day have stuck in my mind. It is indeed intensity that counts. And also the stress he placed on just looking. A university friend of mine once asked me anxiously what you are supposed to do when you go to an art gallery and stand in front of a picture. This I suspect is a common perplexity. I found, and still find, it hard to give an answer. Some people don't find enjoyment in looking at art – or anything – in the way that some don't enjoy music. But if you do feel the 'rhythm of shapes', the sensuality of geometry, and of colour and texture and all the other visual pleasures, it is, as Cartier-Bresson said, a great joy – one that goes on and on, and though it is difficult to explain why, seems filled with meaning.

15 Ellsworth Kelly: Nourishing the Eye

High above the Atlantic, I saw Ellsworth Kellys everywhere around me. The white curve of the aeroplane's wing, the rounded corner of the window against the sky: my surroundings started to resolve into the elegant economy of his abstractions. Major painters are like that. When you are immersed in their work the whole world starts to look different. And Ellsworth Kelly was a master of the ultimately pared-down – perhaps just one colour on a single canvas on a white wall – but his work was somehow not reductive or blank, but full of light and space.

The summons to meet him had arrived at the last minute. Kelly had a big exhibition coming up at the Tate Gallery – not yet divided into British and Modern – in the summer of 1997. *Modern Painters*, a magazine I wrote for regularly, had put in a request for an interview months before. But no definitive answer had come back, until suddenly his studio announced that Kelly would be in a certain restaurant on Madison Avenue at one o'clock sharp in three days' time. I packed a case, bought a plane ticket and went.

The restaurant in question – E.A.T. on Madison Avenue – was neither expensive nor exclusive. Booking wasn't required, which was an

Installation photograph of the exhibition *Ellsworth Kelly: Prints and Paintings*,
Los Angeles County Museum of Art, 22 January – 22 April 2012

advantage in a way, but had the corresponding disadvantage that we
would not be led to the same table and thus automatically introduced.
How, otherwise, could I be sure of recognizing Kelly, since the only
knowledge I had of his appearance came from some small black-and-
white photographs in an exhibition catalogue, the clearest of which
had been taken almost fifty years before, in 1948?

As I usually do on these occasions, I arrived too early, found some-
where to sit and waited while nervously scanning every other male cus-
tomer of approximately the correct age: Kelly, I knew, was in his mid-
seventies. Fortunately, he somehow managed to identify me, suddenly
coming up, spry and vigorous, with the words 'Martin, is that you?'

He sat down, ordered a white-fish sandwich and a beer, extolled
the food at E.A.T. – which was the way he liked things to be, simple,
straightforward, no fuss – and explained that he had elected to meet
here because it would be more convenient for me than travelling to his
studio in upstate New York. To my relief, it rapidly became clear that
conversation was going to be easy.

Soon we got on to the subject of Piet Mondrian, who had ended
his life not far from where we were eating, at 15 East 59th Street. I
told Kelly an anecdote about Ben Nicholson showing the great Dutch

abstract artist his studio in Hampstead, which was almost as spare and geometric as Mondrian's own. After a while, Mondrian had pointed to a tree outside the window and commented, 'Too much nature.'

Kelly capped this with a story about Georges Vantongerloo, Mondrian's colleague in the De Stijl movement, whom Kelly got to know well when he was living in Paris after the war. 'One day I met him and mentioned that I was going to go and stay in the country, and Vantongerloo said, "Ah yes, the country... I went there once."'

Kelly himself, in contrast, found the countryside a much easier environment than the city. 'When I come to New York,' he complained, 'I don't know where to look, everywhere and everything is yelling for me to look, and it becomes like *overdrive*. It's only when I'm in nature, even a storm when everything's moving, that I can feel some sort of stability in form.'

'Birds fascinate me,' he went on, 'I like their colouring and the fact that they fly. Their coloration is almost chance – the red body and the black wings of a scarlet tanager, for example – when you see one, it's really *overwhelming* in colour.'

Then I described my flight, spent alternately dipping into the huge book accompanying his exhibition at the Guggenheim and looking out of the window at the wing cutting into the sky. Its appearance, at that moment, had resembled the Ellsworth Kellys I was contemplating in the book on my knee: like *Dark Blue Curve* (1995) for example, a wide fan shape with a shallow arc at the top. In keeping with a good deal of his later work, it is as much a very thin sculpture as a painting: a precisely configured area of pure, carefully calibrated colour, no frame, poised in white space. (Kelly also made free-standing sculptures, resembling paintings that had escaped from the wall and were standing on the floor.)

Kelly, it seemed to me, was one of those artists who didn't fit easily into art history. He was an individualistic American original, whose work had an absolute purity like that of Shaker furniture or a Navaho arrowhead. It does not belong to, for example, the hard-edge abstraction school, or the minimalist movement of the 1960s.

He was a non-joiner from early on. 'When I was very young', Kelly related, 'I felt that a lot of painting that I was looking at was very personal. It was as if the painter said, "I like to do this, *this* is what I want

to do". But I said to myself, I don't know *what* I want to do right now. But I know I *don't* want to do a lot of things. I don't want to do a portrait. I don't want to do a landscape. I don't even want to do an abstraction. But I felt that you can make a picture of *anything*.'

A revealing, though unexpected encounter took place a few months later between Kelly and Lucian Freud. It is hard to think of two artists who, on the face of it, had less in common. Nonetheless Kelly showed Lucian around his exhibition at the Tate before it opened. And Freud, who was distinctly dubious about this art, pointed to one and said it was his favourite, 'because it had more of the world in it'. Kelly gave him a hug.

Evidently, Lucian had said the right thing. Kelly's art was not based like Mondrian's or the minimalists' on geometry (which is probably part of what he meant when he said he didn't want to make an abstraction). Nor, obviously, was it a picture of something such as a tree or a person. But they *were* derived from a sense of the world, or aspects of it. He revealed to David Hockney that one work, consisting of two different curves, just touching, was suggested by 'two boys' bums' (and, Hockney commented, 'It was very good').

Understandably, this was not one of the examples Kelly mentioned to me, a journalist he had only just met. But he did explain that he had always drawn real objects, plants and flowers particularly, but he wasn't interested in them as a botanist might be, but in their forms, and also in the forms between the forms: 'the way they made patterns of positive and negative space', as he put it. Now, that really does require an artist's eye. How many non-artists go around fascinated by the beautiful gaps between things?

On the plane, I'd read a story about Kelly seeing a woman's green and white scarf in the street, and being so interested that he followed her to see exactly what the proportion of the green to white actually was. I mentioned this and he remembered the moment, long ago, while walking along in New York. 'It was just a certain amount of green and a certain white, and it stood out. And I thought, somehow or other I've got to *make* that.'

But, I asked, what is it about a shadow, or that scarf, that calls to you so strongly? As I should have guessed, he didn't really know. 'They

Ellsworth Kelly, *Briar*, 1961

speak to me, I guess. I don't really search for them, something just all of a sudden hits me, and it stands out. It's like, that's *me* there. I don't understand it that much, but I think my eye does. My eyes are like dictators. I do what my eye tells me, and I've nourished my eye.'

Not long before this, I'd interviewed the jazz saxophonist Sonny Rollins, another major American artist in an utterly different idiom. He had surprised me by confessing he did not understand where his music came from. A stream of notes poured from his instrument, Niagara-like – but he could not turn it on at will, which made performing live in front of an audience of hundreds a little nerve-wracking, although he felt he'd got to the point where he always turned in a decent performance. This, perhaps, is true of all creative activities. We can learn to edit and work with it, but don't really know where the raw material – whether words, sounds, or a sense of form and colour – is coming from.

*

By origin, Kelly was a northeasterner, born in New York State, brought up for the most part in Pittsburgh. But he spent the most formative

years of his career, from 1948 to 1954, in France. So, like James McNeill Whistler a century before, he is an American artist formed in Paris. And there remains a Parisian verve about his work, as well as a New England Puritanism – 'voluptuous' is a word he used several times of colour.

Initially Kelly had gone to the School of the Museum of Fine Arts, Boston, but it was, he explained, in exile in Paris that he found himself. 'When I arrived in 1948 and saw the scene, I realized that I am not European, I am not French, although the artists that I liked very much were from the School of Paris, and the Germans and the Russians. I decided that I didn't want to be a tenth- or fifteenth- or twentieth-rate Picasso, or whatever. I had to think of something *new*.'

'More and more, I wasn't interested in depicting anything. Since the Renaissance, easel painting has been about depiction. I said to myself, I just don't want to depict anything anymore. I want to present something on a one-to-one basis with everything else. You know, like that's a telephone, and that's a bag, and *that's* a painting. But it's not a painting *of* something, I wanted it to be just itself.'

His early pictures often look a little like a Mondrian, in that they are arrays of coloured squares. But the Dutch painter's works were images of an ideal harmony, a microcosm of a Platonic universe, in which every square and block of colour is adjusted to balance all the others. That, Kelly confided, was a way he '*could not* work'. Instead, works of his such as *Colors for a Large Wall* (1951) were arranged by pulling coloured squares of paper out of a hat. The result pops with energy, but it is more dynamic than harmonious.

'I came to a point where I said I want chance to do the work', he explained. 'I don't want to compose; I don't want to try to figure out how this red balances this blue, and the yellow has to go there to make it work here. Warhol was onto things like that too, I suppose. Letting chance work and presenting it in such a way that the personality didn't get between the viewer and the painting. You let the thing itself exist.'

There was, I realized, a sort of Zen about this – and much that he did. Kelly had trained himself to move into a state of consciousness that was purely visual. 'Your eyes are open all the time that you're awake, and you get so used to using the eyes that most of the time

Ellsworth Kelly in his Hôtel de Bourgogne
studio, Paris, 1950

you're thinking rather than seeing. You're not really focusing. But when you start to focus and investigate things, you have to put everything else away.' He once said, epigrammatically, how if you turn off your mind and open your eyes, everything becomes abstract.

Then he remembered an experience he had had long ago. 'When I was quite young, at night I looked into a window from a distance and I saw a red, a black and a blue shape. I was fascinated by what that was, so I went up to the window, but I couldn't find it. I thought, Where did it go? So then I very slowly backed up and realized that it was a black fireplace and a red couch and a blue drape. You know, you forget most of what you do, but I've never forgotten that.'

*

After lunch, we stepped outside and Kelly took me round the corner to the Knoedler Gallery, where he commandeered a spare office for us to talk in. And fairly soon I began to be given practical demonstrations of how his eye worked.

'When I was in France,' he explained, 'I became more and more interested in details I would see of architecture. Things like subway grilles in the pavement, and the structure of buildings in Paris. I was very selective. Like, for example, look at this wall here.'

Kelly pointed to a corner of the nondescript room where we were now talking: 'Where that chain on the window blind is, it's very light, and between the bottom edge and that angle – *there's something happening there*. I said to myself, I don't want to paint that, but want to make something that's *like it*. I want to construct something that has that quality, that compression.'

This was startling; I was being shown my surroundings through Kelly's eyes. All around in this utilitarian place just like a million others, he saw exciting possibilities. He turned his head and spotted another. 'That top set of books over there that are leaning and all the same, and the dark lines between them and the way the red works with the blue – I feel, well, that could be a painting.'

Like Kazimir Malevich, Kelly had produced a 'Black Square' and a 'White Square'. However, whereas the Russian painter's celebrated works, the alpha and omega of abstract art, were intended to be redolent of ultimate truth, Kelly's were based on a window he had seen in a Parisian café terrace (in fact the frame and the square are painted on separate supports, just like a window and its frame).

At one point, Kelly had taken many photographs in a stark black-and-white vein – the void of a barn door, the shadow cast by a farmhouse eave – glimpses, fragments of things seen that he wanted to record. These were beautiful in themselves, but Kelly found he couldn't work from them. He tried once, he said, but it 'lost its magic'. The problem was that in working from a photograph, you were 'starting from something that's already finished'. It would be the same if someone attempted to make a painting from a photograph by Henri Cartier-Bresson or Robert Frank, whom I met a few years later.

16 Robert Frank: It Changes all the Time

Robert Frank suggested I should meet him at a hot-sausage stand opposite the biggest tram station in Zurich, the one at the end of the line. It seemed quite appropriate, since Albert Einstein apparently first had an inkling of his theory of relativity while travelling on a Swiss tram. And Frank, you might say, was the man who brought relativity to photography. As his friend the poet Allen Ginsberg observed, he invented a new way of seeing, 'spontaneous glance – accident truth'.

All the same, there was something alarmingly casual about this arrangement. I had never been to Zurich before, and therefore had no knowledge of its public transport routes or the snack stands that might be located nearby. So it was without much confidence that in the autumn of 2005 I caught an early plane, took the train into the city and climbed aboard a tram.

However, near the terminus, there was indeed a little hot-dog stall. I stood next to it, uncertainly. Then, at the appointed time, an elderly man strolled along: Robert Frank arriving with an appropriate mixture of informality and precision. He was just what you would expect from

a description by Jack Kerouac I had read an hour or two earlier, 30,000 feet up in the sky: 'Swiss, unobtrusive, nice.'

Apologetically, he explained that he had chosen the bratwurst stand at the tram stop because it was easy to find and he liked the sausages (which were delicious). But it also seemed a Frank sort of spot: unexpected, informal and with an excellent view of the world passing by.

Zurich looked as if it hadn't changed much since Einstein had his tram-board epiphany, before the First World War. For that matter, Frank seemed so at ease in the city that he might have lived his whole life here. The latter would have been a false deduction. Frank had been around the globe before making this return visit.

As for the world itself, he observed as the trams rattled by, 'it changes all the time and it doesn't come back'. The photographer, therefore, is subject to a version of Heraclitus' Paradox. That Greek philosopher noted that it is impossible to step into the same river twice – since by the time you do the water will have changed and so will you. Similarly, you cannot take the same picture twice, especially if, like Frank or his predecessor, Cartier-Bresson, you are operating amid the flux of reality.

*

After a while, Frank suggested that we should move on from the tram stop to a nearby restaurant, the Haus zum Rüden, which was solid, old-fashioned and quiet with good rösti on the menu. It represented, in a way, everything the young Robert Frank had escaped.

'When I come back here,' he exclaimed, 'I can't believe it. It's privileged, that's what it is! To me it's a bit like a university campus. The water in the lake is clear when you look down – fantastic. When I was younger I walked away from it. Now I'm attracted to this peace.'

Frank was born in Zurich in November 1924, and comes from a cultured Jewish family. His father – who owned a business that imported radios – had moved to Switzerland from Germany. During the war Switzerland was an island of safety in Nazi-controlled Europe. But as soon as the war was over, Frank wanted to get away into the wider world. He didn't want the smallness of Switzerland, nor did he want to

follow his father into the business. One route out was suggested by a neighbour in the attic above the Franks' flat.

'That man was a very big influence on me. He was a wonderful man – very quiet, he couldn't hear very well, with a lot of knowledge of contemporary art. My father always talked about old art. So, because of this man, I saw that there was a different life than the one my parents led. He would gently tell me what you could do with photography.'

As a young man, Frank learnt from older photographers, particularly Bill Brandt in London and Gotthard Schuh, who was Swiss. But – he added – 'Some of the painters I knew taught me more about seeing than Brandt did.'

'I liked watching people', Frank mused on his work of fifty years before. 'I'd be very patient doing that, watching someone going down the street perhaps, tying his shoes. Then I'd have to be quick to take something. You have to be *ready*.' After a pause, he went on: 'I was very free with the camera. I didn't think of what would be the correct thing to do; I did what I felt good doing. I was like an action painter.'

Action painting, now more often called Abstract Expressionism, was an idiom that had only recently appeared when Frank first arrived in New York in 1947. Jackson Pollock began his drip paintings in that year. Mark Rothko and Willem de Kooning were at the height of their early maturity as artists; jazz too was all around, and Charlie Parker's bebop a radical new musical style. All of this and the city itself struck Frank – aged 23 and just off a boat from Europe – as 'wonderful'.

The voyage across the Atlantic had been exactly what the well-worn phrase describes: a rite of passage. 'It was a long voyage on one of those Liberty boats that used to bring over arms to Europe during the Second World War, with only twelve passengers', he told me, looking at the autumn sun on Lake Zurich: 'There were storms, it was unforgettable for me.'

On board, he took a marvellous shot on the ship with a young man – another passenger – leaning on the rail and behind, slightly out of focus, the sea, a swirling chaos filled with infinite possibilities.

*

In New York, Frank lived around 10th Street, then a warren of abstract artists' studios. De Kooning's studio was across the courtyard: Frank would watch him pacing backwards and forwards, agonizing about what brushstroke to make next on his current canvas. Later, around 1961, Frank took a superb shot of De Kooning standing in the street at night, the lights of the city shimmering in the background.

De Kooning was not, or not often, an entirely abstract painter. His pictures were more usually anchored somehow to the world, to a landscape or a human body. But content, De Kooning told the critic David Sylvester in a frequently quoted interview, was, as far as he was concerned, a glimpse. 'A glimpse of something, an encounter, you know, like a flash – it's very tiny, very tiny, content.' Nonetheless, that instant of revelation stayed in his mind while his picture might change all the time: 'I still have it now from some fleeting thing – like when one passes something, you know, and it makes an impression.'

It struck me that Frank's own photography could be described in the same way: fleeting glimpses. He agreed, then told an anecdote from half a century before. 'One day De Kooning said to me that he had passed by the Matisse Gallery and seen the show from the street: "I didn't need to go in, that was *just enough*." The way he said it was wonderful.'

Sometimes a glimpse can indeed be sufficient. Seeing – and understanding – can be extremely fast as well as very slow. You can look at a great painting, a De Kooning for example, for hours, for your whole life. But it's also possible to comprehend a sight in an instant, far quicker than you could put it into words. The art historian and museum director Kenneth Clark said he could tell a good painting from a bad one while going past it at 30 miles an hour on a bus. He wasn't much exaggerating. Sometimes you can.

The other thing Frank learned from painters, he went on, was to do with nerve. 'These artists primarily showed me that if you had the courage to do what you felt was right, or what you really wanted to do, you could succeed. I would watch them very carefully. I was always a photographer, but I learned that if you followed this dream, you could do it, maybe not get to the top. But it was worthwhile doing it.'

Once in New York, he had got a job on *Harper's Bazaar*, an achievement for an unknown youngster who had just stepped ashore. But after

Portrait of Robert Frank by Allen Ginsberg, 1984

a while Frank didn't want to work on fashion shoots, and he didn't like the control that magazine editors had over his work. 'When you are new to a country, you are excited, you *watch*, and I found out very quickly what I did *not* want to do.' Instead, Frank took off alone, taking his own kind of pictures.

In 1948, instead of doing fashion shots for *Harper's*, Frank went to Peru. At that time he was reading the works of the French writer and thinker Albert Camus, whose central character in his novel *L'Étranger* of 1942 was a lonely misfit in an indifferent universe.

'I was an outsider,' Frank reflected, 'I read a lot of French books then – all of Camus's – which made a big impression on me. Maybe I didn't understand them too well, but intuitively I got something of his view of the world, which influenced me. I felt I didn't have to say, "Here's a view of an ancient Inca city that I've brought back for you". I could just look at the country for myself.'

In the 1940s and 1950s he was an isolated individual with a camera making choices, one after another, from the kaleidoscopic stream of

appearances: an existential hero with a camera. After Peru, he went on to Paris, Spain and Britain. In those days he felt 'a bit like a detective' following someone – a city banker, for example, in dark coat and top hat patrolling the funereal streets of London – whose face or way of walking caught his attention.

Instead of single images, by the mid-1950s Frank began to think in terms of sequences, which added up to 'a vision or something'. In 1956, he was awarded a Guggenheim Fellowship that paid for a journey that took him through forty-eight states and from which he selected eighty-three shots that made up *The Americans* (1959), one of the most celebrated photo-books ever produced. Frank and his wife, Mary, just drove off, with two young children. She set out feeling they were going on 'some sort of picnic'.

But their American odyssey turned out to be no picnic. In Little Rock, Arkansas, Frank was jailed for looking foreign and taking pictures. It took three days for him to get out. 'I had never seen America from coast to coast,' Frank recalled. 'It was my first trip really. It's a very tough country, and I gravitate to people who are not winners. There were a lot of heartbreaking streets. I was drawn to that – how tough it was and how tough *they* were.'

The pictures Frank took en route were visibly done at speed, with minimal equipment – just a lightweight Leica hanging from a strap around his neck. Sometimes tilting, sometimes blurred, they looked *fast*.

While he was driving through the US, a then unknown writer called Jack Kerouac was trying to find a publisher for a book about just such a helter-skelter flight across the country. He called it *On the Road*. Frank met Kerouac in late 1957 or early 1958, after the book had finally come out. He was still searching for someone to publish the photographs from his own trip – which seemed shockingly raw and harsh to the middle-class New York publishers he was showing them to. This was not an America they recognized.

In contrast, Kerouac appreciated them on sight: 'You got eyes', he told Frank in compressed, hipster-speak. Kerouac wrote an introduction for *The Americans*, and the two men went off on a road trip together across Florida. Nonetheless, they saw this terrain differently. Although Kerouac had no time for the squares who inhabited much

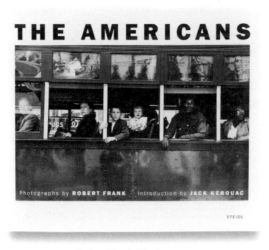

Robert Frank, *The Americans*

of the country, his writing is a paean to America in all its vastness and freedom. 'Jack really loved the country,' Frank reflected. 'His descriptions of America are among the most beautiful pieces of writing, to me.'

To his own European eyes, the USA was a fascinating place, but a dark one. 'I didn't feel like Jack about America. I feel more that way now. But America hasn't changed; in fact I think it's harder. Then there was really hope among the younger people, it was a great time to create something and to be in the company of people who would understand it. They called you a dirty beatnik, but it was fun. That doesn't exist anymore. I was lucky to live through it and learn from it.'

*

Surprisingly, or perhaps not, as our conversation continued over another course and coffee in the elegant dining room of the Haus zum Rüden, it emerged that Frank was a little doubtful about the medium that had made him famous.

'I always had my doubts about photography, because it's made by a machine, then duplicated by a machine. I always wished that I could start with an empty sheet and make something like a painter.'

He was surrounded by painters in New York – not only De Kooning but also Rothko, Barnett Newman, Helen Frankenthaler – and engagingly modest in his attitude to them. 'Of course, they were artists, I was a photographer; so I was really on a lower level.' However, he had a painter's instinct – the ability to see a potential picture almost at the speed of light.

Even in the confines of photography, Frank was restless. 'I always had to move to another camera to get something different.' Soon he moved out of it altogether. 'I didn't want to have that Leica around my neck anymore; I said to myself, I'm through with that!' One day he went to see Kerouac and suggested they make a film. The result, Pull My Daisy (1959), had an improvised narration by Kerouac and featured various Beat figures including Allen Ginsberg, Larry Rivers and Alice Neel.

In addition to film, Frank explored and invented various idioms: photo-collage, often with written messages on them; and multiple images set side by side, which were not far from the idiom of Gilbert & George's pictures of the 1970s, or Rauschenberg's Combines. In any case, as Frank pointed out, photography had changed hugely since the 1950s. Digitalization had made the image much more easily manipulable, closer in a way to painting. The hand, as David Hockney liked to point out, was back inside the camera.

During Frank's lifetime, so much had changed, while other things – like this Zurich restaurant – had remained much the same. Now, here he was back again, sixty years after he had left. Before we said goodbye, he looked back, a little melancholy, but not regretful.

'I'm an old man now, and I can say it was very good, because it made sense somehow, much more than my father's journey through life. That wasn't a very happy trip. It all seems to fall apart at the end; like life falls apart, your body falls apart. But it's good if you can work as long as you can.' Photographers, like painters, seldom retire.

CHANCE AND NECESSITY

17 Gerhard Richter: Chance does it better than I can

'Why do people listen to Wagner?' Gerhard Richter asked over a restaurant table in Cologne, 'I just don't understand it'. Then he looked quizzical and laughed. Personally, Richter confessed, he was allergic to the sound of *Tristan* and *Götterdämmerung*, but – to his annoyance – when he turned on the radio in his studio that morning, that was exactly the grandiloquent sound what came out of the speaker. So he turned it off and put on something more to his taste: a piece by the austerely minimalist American composer Steve Reich.

His Wagner-phobia made perfect sense. Richter had a very un-Wagnerian presence: small, neat, self-deprecating and wry. It was hard to imagine anyone who behaves less like Siegfried or Wotan. He was the opposite of Gilbert & George or Marina Abramović: a non-performance artist. In his art, the artist is absent – or so, at least, it seems.

Over lunch, Richter confided his misgivings about Joseph Beuys, a teacher at the Kunstakademie Düsseldorf when Richter was a student there in the early 1960s, and later a colleague at the same institution. Beuys was the most renowned of postwar German artists – at least

before Richter himself came along. He was 'a little sceptical' about the older and more famous man. 'I felt he was a bit of a maniac.'

Like G&G, Beuys wore an artist's uniform of his own devising, in his case consisting of felt hat, American fisherman's jacket, Levis and English shirt. The hat kept his head warm, but the clothes also served to make him instantly recognizable. In contrast, Richter scarcely ever appears in his own works. One exception is a picture from 1996, apparently based on a snapshot so fuzzy as to be almost unrecognizable. As a result, before we met I had little idea what he looked like. His clothes – a quiet suit, no tie – were reticent to the point of invisibility. It seemed improbable he might be hailed by fans in the street, in the same way as G&G or Beuys.

In addition to making paintings, sculptures and installations, Beuys performed. He once spent several days in a cage trying to communicate with a coyote, and famously attempted to explain art to a dead hare. 'Beuys was important of course', Richter mused, '…a great entertainer. I wasn't able to speak as well as he could. I just kept quiet.'

In his opinion, though, 'Art should be serious, not a joke. I don't like to laugh about art.' But, Richter added happily, 'I am ridiculously old-fashioned'. And there I suspected he was joking, just a little; after all, he was one of the most radical painters alive, a superstar of contemporary art, at that time regularly heading polls of the most admired artist alive.

All the same, Richter confided, politically he was, 'naturally a conservative'. However, he stressed that this was both inevitable – 'Everybody is a bit of a conservative, you have to heat your flat and cook your food' – and simultaneously impossible: 'Actually you can't be because the conditions don't exist to be one.' In other words, he *would* be a conservative, if there were anything to conserve. This in a way was the story of his life and career: continuing to work in a medium – paint – that was widely believed to have died long ago.

I asked why, then, he still believed in painting. His answer was minimalist, almost fatalistic. 'I believe in eating too. What can we do? We have to eat; we have to paint; we have to live. Of course not everybody paints, there are different ways to survive. But it's my best option. I didn't have so much choice when I was young.' This answer reminded me of a line by Samuel Beckett: 'You must go on, I can't go on. I'll go on.'

*

Gerhard Richter in his Cologne Studio, 2017

It was the summer of 2008. I had flown to Cologne the day before to talk to Richter. I spent the night in a hotel next to the Cathedral, one of the central monuments of German culture. Begun in the Middle Ages and finally completed hundreds of years later in the 19th century, this building is both medieval and romantic. It remained standing amid the bombed-out ruins of the city, a mystic vision of fretwork towers and pinnacles. Today, Cologne is a three-dimensional collage of old and new: concrete ramps, steel and glass and reconstructed Romanesque churches.

What happened to Cologne during the war was apocalyptic; Richter's early years were like that too. In the words of the American critic Peter Schjeldahl, he 'grew up and came of age in the modern regions of Hell'. As a 13-year-old, Richter saw the glow of the Dresden firestorm on the horizon, like an inferno by Hieronymus Bosch.

He was born in 1932 and lived during his early years in small villages outside Dresden where his father worked as a teacher. As a state employee, his father was compelled to join the Nazi party. His mother's

brother, Rudi, joined the army and was killed shortly afterwards. The darkest was the fate of her younger sister, Marianne, a schizophrenic. Among his early works are several based on family snaps. *Aunt Marianne* (1965) shows a smiling teenage girl with an anxious-looking baby on her lap – the infant artist. Marianne was later murdered in a Nazi programme to exterminate the mentally ill.

After breakfast on a terrace with a view of the Cathedral, I took a taxi to Richter's office, unnecessarily, as it turned out, since it was quite close. At first, the conversation had not flowed with ease. For one thing, we were talking through a translator, since Richter was not confident about his English (later, it turned out to be not bad at all, certainly much better than my German).

To start the conversation, I began by asking about his daily routine. But that, unexpectedly, led us straight into the complexities and con-tradictions of what he did. It seemed that Richter thought about his pictures as having independent lives of their own. 'I work on, say, six works at the same time. They learn from each other. One is better here, worse there, so I change it. Finishing is the most difficult thing.' Then he quoted Goethe's *Wilhelm Meister*, 'Every beginning is cheerful; the threshold is the place of expectation' (Aller Anfang ist heiter, die Schwelle ist der Platz der Erwartung).

It's what comes after the cheerful beginning that's difficult (true of so many things, including travelling and writing books). Richter believed in doggedly carrying on. 'Several hours of painting in the studio in the morning and two more in the afternoon. Every day is not possible; you don't have the right mood every day. But that's the ideal.'

Richter had had a good summer three years ago, he added: 'three months and six large paintings'. He named them after John Cage, the avant-garde American composer who had once announced, in his 'Lecture on Nothing', 'I have nothing to say and I'm saying it.' Perhaps that was true of Richter too.

Since the early 1980s many of his abstracts – a large subdivision of his work – had been worked over with a squeegee, which he used to smear, drag and erase what he had done, again and again. Each paint-ing, he explained, 'Starts like an accident, then something happens and

something else happens'. From the way he talked, it almost sounded as if Richter was a passive spectator. The picture painted itself, assisted by the artist using a slab of rubber that was like something from a car-wash place.

Yet there was a paradox: these squeegee abstracts by Richter are filled with light like a Monet painting of the lily ponds at Giverny. They make you think of sunshine on water, reflections on the surface, dark depths beneath. Richter makes you aware of the illusion of shimmering beauty – and at the same time rubs in the fact that what you are looking at is just haphazard marks made by pushing pigment around: chaos, a picture of nothing.

In fact, a great deal of life and art is about serendipity: discovering shapes and forms in the confusion around us, beginning with those prehistoric painters noticing that a mark on the side of a cave looked a bit like a bison, or Leonardo looking at an old, stained wall and seeing battles or landscapes. 'Chance does it better that I can,' Richter explained modestly, but immediately added, 'but I have to prepare the conditions to allow randomness to do its work.' Here was another paradox. Richter was at once the humble servant of accident – and its master, controlling the random events that occurred on his canvases like a scientist in a laboratory. Picasso once famously said, 'I don't seek, I find'. And of course Marshall McLuhan noted that the medium is the message: the message of Richter's abstractions could be that the universe is a gigantic Rorschach inkblot, into which we read beauty and meaning.

Perhaps the message was correct. 'Randomness is an important theme to me because it's the same in life,' Richter said. 'Chance determines out lives in very important ways. If he hadn't met her, what would have happened to them both?'

What would have happened to Richter himself, I wondered, if he hadn't left East Germany as a young man, in March 1961, shortly before the Berlin Wall was built. I repeated an observation that another celebrated German painter, Georg Baselitz, had made to me: that most of the leading postwar painters in Germany, including Sigmar Polke, Richter and Baselitz himself were all exiles from East Germany. Richter laughed, then thought about it.

Gerhard Richter, *Ema (Nude on a Staircase)*, 1966

'Of course, the more energetic people are the ones who leave – that's the simple explanation, but it's not that simple. We saw modern art in magazines, but we were hungry to see it. When you have everything, naturally you are not so hungry.'

In a couple of ways, the art students of East Germany were in a similar position to those in 1950s Britain. They were in a provincial backwater, getting glimpses of exciting radical things happening elsewhere, in New York and Paris. At the same time, they were being trained in a thorough, old-fashioned way: how to put paint on canvas and draw a naked human being. Richter and Baselitz in Dresden had that in common with, say, David Hockney in Bradford.

Richter's first big commissions, before he left for the West, were for murals: *The Joy of Life* (1956) for the German Hygiene

Museum, and *Workers' Uprising* (1959) for the Socialist Unity Party Headquarters, both in Dresden. These were projects, if not necessarily subjects, that would have made perfect sense to Tiepolo. For that matter, it seemed, Tiepolo – or Titian, or Vermeer – felt like colleagues to Richter.

'I was conscious of a great tradition. Even when there were more ruins than houses the tradition was there.' Then he added, 'I still have that feeling today. I'm not a modernist. I love the values of the old traditions.'

'Gerhard Richter not a Modernist' might seem as improbable a headline as 'Pope not Catholic'. On the other hand, he has often said that in an ideal world he would like to paint like Vermeer of Delft, and he said as much to me. 'Maybe with a little melancholy because I have the feeling that it's not possible to paint like Vermeer anymore, because that whole culture is gone, we've lost our centre. We just have complete freedom. You see it every day, how free we are.'

Perhaps that's why Richter's art comes in two modes: abstract and figurative. The latter works are visibly based on photographs, but not exactly *of* photographs. 'I am not very interested in photography as an art. They don't touch me that much,' Richter admitted. What he seems to be interested in is the way the camera lens *doesn't* show us the world around at all – the out-of-focus blur and smudge, what you might call visual interference.

The people in Richter's pictures, often based on snapshots, are like ghosts, weightless, disappearing into a void. Critics have described them as super cool. Thinking I was just repeating the standard line, I said these paintings seemed to express absence, alienation and a sense that the past is unattainable. Unexpectedly, Richter completely disagreed. 'That's not what I think about my pictures. I feel the opposite: that they are shameless, so directly showing what I am thinking and feeling. I'm not really a cool artist.'

His painting of his aunt Marianne contained terrible memories, whereas *Ema (Nude on a Staircase)* (1966), a picture in the Ludwig Museum here in Cologne of Richter's first wife, nude, walking downstairs, was full of love and sensuality. If Vermeer had ever painted a naked portrait of his wife, it really might have looked a bit like this.

Cologne Cathedral, south transept window,
based on a design by Gerhard Richter, 2007

Only many years later did he discover that Ema's father had been the commandant of the camp where Marianne died.

Richter's work often *looks* cool, but perhaps there is emotion and meaning concealed even in the most impersonal and abstract. At the time we met he had recently installed a huge expanse of pixelated, coloured squares in what looked like Brownian motion in the gothic south transept of Cologne Cathedral. The original proposal for the window had been for him to produce images of 20th-century martyrs, killed by the Nazis. 'I was surprised and I said I would have to think about it. It was so attractive to get the opportunity to make a window in there that I couldn't say no.'

But after trying for a while to make the martyr theme work, he concluded that it wouldn't. Then, when he was playing around one day with a reproduction of one of his abstract paintings of coloured

squares, he dropped a template of the window over the abstraction and – he thought, 'My God! That's it!' He told the cathedral staff that this was the only kind of window he could make. 'We talked about it again and again, then finally they said, "OK, we'll do it." It was brave of them.'

For this medieval monument to religious faith, Richter had devised a window of 11,500 hand-blown glass panels in seventy-two shades compatible with the existing stained glass. They were made and put together in accordance with a randomizing computer programme.

But Richter set the ground rules. 'I have to arrange the right proportions – the balance of different colours, the scale, which colours I prefer.' He only overrode the dictates of chance once: 'In the first part of the window, it was possible to see a letter "I".' So Richter removed it to make the window look *more* random. He was modestly cautiously pleased with the result. 'It fits. I was lucky; it could have failed. With a painting you can go over it again and again, but with glass you've got no chance to do that.'

Shortly afterwards, without referring to Richter's window directly, the Archbishop of Cologne, Cardinal Joachim Meisner, observed that when culture is cut off from God it becomes 'degenerate'. That really stirred things up because degenerate – in German, *'entartete'* – was the word used by the Nazis to describe modern art. The Cardinal was angry, Richter told me, because his window is not a Catholic window. Then he wryly repeated Einstein's remark, 'God does not play dice'.

At our lunch following the formal interview, Richter visibly relaxed, becoming funny and almost gossipy. After we had said goodbye, and before catching a flight home, I wandered into the cathedral. Richter's strained glass looked fabulous: flickering with light, absolutely contemporary, suggestive of some infinitely complex system. You could see why the Cardinal thought it was scandalously irreligious. On the other hand, Richter was quite right to say that it fitted. It struck me as a marvellous image of what the 17th-century philosopher Spinoza called 'nature naturing': as if you were looking at electrons, molecules and photons in action. And who knows, perhaps Einstein was wrong. When he remarked that God does not play dice, Niels Bohr, another great physicist, responded: 'Don't tell God what to do!'

18 Robert Rauschenberg: A Turtle in the Elevator

Shortly before meeting Robert Rauschenberg in New York, I collided with an iron post sticking up out of East Houston Street. I had been walking along, thinking about the questions I was going to ask the artist, my head full of thoughts about his work, and simultaneously looking for a gap in the traffic through which I could nip across the road, when Bam! my forehead and nose connected with metal.

In its way, this was a suitable preliminary to a meeting with this contemporary master: a sort of updated, Americanized equivalent to those stories in which Zen Buddhist masters, in order to induce *satori* or enlightenment in their pupils, may give them a sudden surprise, such as a bash over the head with a bamboo pole.

My encounter with Rauschenberg began with a series of such unexpected events. When I had recovered, I crossed over to Lafayette Street and rang the bell of Rauschenberg's New York headquarters, which was housed in a four-storey former Mission of the Immaculate Virgin, a Catholic orphanage (with gothic windows). The doors opened on a long room that was completely empty, except for large works by Rauschenberg. I walked to the far end, and entered an

elevator. Inside was a notice warning the occupant, on leaving, to beware of the turtle.

I wondered, as the elevator rose, whether – given that Rauschenberg was one of the foremost living adherents of Marcel Duchamp – this was a Dadaist leg-pull. But no, as the elevator doors opened on the top floor, there, gnarled and nodding, was a genuine turtle. And behind, friendly and welcoming with outstretched hand – 'Hi, I'm Bob' – was Rauschenberg himself. He explained that his pet was inclined, unless prevented, to clamber slowly into the lift, a bad place for aquatic reptiles. This incident, with its combination of straight-forwardness and utter-unexpectedness, turned out to be characteristic of Rauschenberg.

'Bob' had been one of the pioneers of just about every artistic innovation in the second half of the 20th century from performance art to installation. In 1951, years ahead of the curve, he had made monochrome all-black and all-white paintings. Thirty years before Damien Hirst, he had been using stuffed animals in art. In his early seventies – he turned 72 a few weeks after I met him – Rauschenberg was one of the living monuments of modernism.

I had spent the previous day viewing a colossal retrospective exhibition of his work that filled both the uptown Guggenheim Museum and a downtown offshoot. Both had been closed to the public since it was a Thursday, the institutional day of rest, but opened to me on Rauschenberg's instructions because he wanted me to see as much as possible of his life's work before we spoke. This was a neat example of a paradox at the heart of his life and art. He was, as I discovered, the most informal, unassuming of men. As an artist he had embraced randomness, the ordinary, the humble, the everyday; his approach was the opposite of masterful and egotistical. Yet somewhere there lurked a masterful ego – there had to be, perhaps. At his word, the doors of the Guggenheim sprang open and I obediently entered.

I had wandered through the vacant galleries with an attendant pacing beside me. That morning I had visited a private gallery in SoHo where Rauschenberg's *¼ Mile or 2 Furlong Piece* was on display. At that point the work was 790 feet long, though it grew longer before Rauschenberg's death over a decade later. It consisted of virtually every kind of photographic imagery imaginable, plus such items as traffic

lights, a sickly looking prickly pear and speakers emitting various kinds of found sound.

In the apartment we settled down at a table in Rauschenberg's kitchen, where the great man was sipping chilled white wine. This room was dominated by a magnificent black cast-iron range. Rauschenberg, it soon emerged, loved cooking, and gave a characteristically oblique account of why he liked it: 'It's a very social way just to turn your back and still be there.'

On the range there perched a television. He kept this on while we were chatting before the formal interview began, managing to talk almost continuously while simultaneously taking in the soaps. When I switched on my tape recorder, he turned down the sound, but a constant drizzle of images continued in the background.

This seemed a natural environment for Rauschenberg. As a young man, he once said, he had been 'bombarded with TV sets and magazines, by the refuse, by the excess of the world'. He thought then that an honest work of art 'should incorporate all of these elements, which are and were a reality'.

Such was already the texture of American life in the 1930s and 1940s when Rauschenberg was growing up; it was a great deal more so in 1997 when I met him. 'I am always surprised,' Rauschenberg observed, 'that in this day and age, people don't keep up with *everything*. You don't have to look for information. We're *swimming* in it.' That drenching deluge of data which surrounds us in contemporary life was his true subject.

In common with quite a few visual artists, Rauschenberg suffered from dyslexia. This was perhaps an advantage. Many people operate by concentrating on one thing at a time; Rauschenberg thought there was a great deal to be said for being aware of as much as possible, concurrently.

From the beginning, his art aimed at the maximum inclusiveness. An early project (understandably an unrealized one) was to make a complete photographic record of the USA, foot by foot. Later in his career, he threw out the idea that there was no reason not to consider the whole world as one big painting. Evidently, he was not a man who liked to leave anything out of the picture.

Robert Rauschenberg, *Canto XIV: Circle Seven, Round 3,*
The Violent Against God, Nature, and Art, from the series
Thirty-Four Illustrations for Dante's Inferno, 1958–60

When the interview began, it was not long before the subject of religion came up, as this was on Rauschenberg's current radar. He was in the process of creating a huge contemporary vision of the end of the world for a cathedral in southern Italy. This was an odd assignment for a major master of contemporary art, made stranger still by the fine print of the commission. The Franciscans who were in charge had explained that this church, dedicated to Padre Pio, was a place of healing so they didn't want it to be an unhappy apocalypse. 'Are you reading the same book I am?' Rauschenberg had responded. On the other hand, the Last Judgment viewed as – to borrow a period phrase – a 'whole earth catalogue' might be right up his street.

He had had, it soon emerged, an old-fashioned religious back-ground. Rauschenberg was born and brought up in Port Arthur, Texas, and his speech still retained a Southern lilt. In ancestry he was a human collage of northern European and Native American elements: Dutch, Swedish, German and Cherokee. His mother was extremely devout. 'I was brought up as a fundamentalist,' he told me, 'so fundamental that we made the Baptists look like Episcopalians.'

As a teenager he decorated his room with imagery painted over the walls and furniture, plus found objects, in what sounds like a prede-cessor of his later all-encompassing painting-cum-collages. The young Rauschenberg kept numerous pets, predecessors of that turtle, and loved dancing.

His discovery that the church his family belonged to banned dancing ended his early ambition to become a preacher. 'I left the church,' he explained, 'because I did not believe that life was to be spent thinking that everything in the world was evil. But the church showed me what I was: that I wasn't interested in value judgment and condemnation as a life style. I did not believe in goodness coming from fear.'

That was perhaps why Rauschenberg had a bone to pick with Dante Alighieri. It was, perhaps, a sort of lovers' quarrel across the centuries, since between 1958 and 1960 he produced a delicate cycle of works based on Dante's *Inferno*. However, he had almost failed to complete the project – appalled, he explained, by the hypocritical mor-alizing of the author. In particular, he singled out the episode in Canto XV when the poet encounters his old teacher Brunetto Latini among the sodomites, condemned to jog eternally across the burning sands of Hell. '*Siete voi qui, ser Brunetto?*' Dante exclaims in surprise. Or, as Rauschenberg freely paraphrased, 'What a surprise seeing you here! I'm so *sorry*.' But, he protested, 'Dante wrote the fucking thing!' I liked the easy familiarity with which he took on the great poet.

The revolt against his family's piety was the first of Rauschenberg's rebellions against rigid systems of rules. During the war, which he spent nursing traumatized sailors, having told the US Navy that he did not want to kill anyone, he decided to become an artist. In 1948, at 23, he found his way into Black Mountain College, in North Carolina,

then one of the most extraordinary centres of avant-garde thinking and teaching in the arts anywhere in the world.

Among the faculty were the architects Buckminster Fuller and Walter Gropius, the composer John Cage, dancer Merce Cunningham and artists such as Willem de Kooning and Robert Motherwell. But here too, though Rauschenberg learnt a lot, he also found much to reject. He confided: 'It was almost like the church when I was at Black Mountain.'

His 'greatest teacher', he told me, had been Josef Albers, a former professor at the Bauhaus, and refugee from Nazi Germany. 'The more Albers told me what he felt, the more I thought, Well isn't that wonderful? – for you, but I feel just the opposite.' Albers made hundreds of abstract paintings in a series entitled *Homage to the Square*, all with similar compositions of squares nestling within squares in differing combinations of colour.

It is true that early on Rauschenberg produced some paintings even more austere than his teacher's, canvases painted entirely in white, for example. These he explained as the result of a militant desire to be fair to paints. He hated the way painters picked on 'innocent colours' and forced them to express their emotions. He didn't think artists should make pigments, or anything else, express their feelings. This, for him, was a moral question. 'I've found – I think as everyone finds – that the focus on the self, particularly through pity – is about the worst state, the most anti-life, that you can put yourself into.'

Rauschenberg, then, wasn't an abstract expressionist; he was an anti-expressionist. 'I managed to be sterile enough to do all-white paintings,' he remembered, 'because I would not choose one colour over another.' But it is hard to imagine anything much less austere than the works that he was making a few years later.

It is true that there was not actually a kitchen sink included in these 'Combines'; there was certainly just about everything else. Examples from the late 1950s incorporated, in addition to the paint and canvas, a bed, umbrella, broom, electric lights, coca-cola bottles, a telephone directory, door, stuffed eagle and an Angora goat.

The last of those items features in one of Rauschenberg's most celebrated works, *Monogram* (1955–59). He had seen the goat in a second-hand furniture store on Seventh Avenue, paid $15 towards the asking

Robert Rauschenberg with *Satellite* (1955) and the first state of *Monogram*
(1955–59; first state 1955–56), New York, *c.* 1955

price of $35, and took it back to his studio. Over the next four years
it formed part of a series of pieces until it reached its final form,
encircled by a car tyre. The problem, he explained, was that the goat
'was so *noble*'.

'My idea was that the tyre was as stately and dramatic as the goat,
yet they shared the same world. But I didn't reach that as a conclu-
sion through any psychological, mythological or sexual harassment.'
He took strong exception, it transpired, to the celebrated analy-
sis of the piece by the critic Robert Hughes in *The Shock of the New*
(1980). Hughes, with typical verbal gusto, and doubtless conscious of
Rauschenberg's sexual orientation, described *Monogram* as 'one of the
few great icons of male homosexual love in modern culture: the Satyr
in the Sphincter'.

The artist vehemently rejected this account: 'Most art critics, if you
tell them they can't use any sexual interpretations, they go mute. They
don't know what they are looking at. It's like candy is sweet; nobody
buys bitter candy. It's a cheap trick. I don't know how you would get
anywhere – if everything had to be read through sexuality.' Here was
another lesson: how artists see their work may be diametrically differ-
ent from how it is understood by critics and historians.

How, I asked, did he choose the strange assortment of ingredients
that went into his art if not to tell some sort of story? 'I am looking
for everything; and what I get home with is *some* of everything.' But
it turned out he particularly favoured things that did not have any
symbolic or cultural meaning, or, as he put it, had not been 'psycho-
logically digested'.

'Such as?', I asked. 'A broom, for example, although there is a bit of
witch in there.' Or rubber tyres: 'Particularly in the States, you cannot
walk around a block without seeing a discarded tyre; it's nice to find a
very generous round thing. Free.'

He didn't want to express his own prejudices, Rauschenberg went
on, so as far as possible he tried to work as though he himself wasn't
there at all. 'I want to surprise myself!', he exclaimed, 'I want to be the
first one to not-know what I am going to do next; I would also like to
be the first one to be confused and bewildered by what it was I did do
next, after I've done it.'

He acted on just that principle in 1964 when he won the Grand Prize for Painting at the Venice Biennale. This was a historic victory, which sent shock waves through the European art world, and has often been viewed as marking the moment at which New York definitively took over from Paris as the world capital of culture.

The works for which he won that prize were silk-screen pictures in which a multiplicity of imagery – photographs of President Kennedy, space rockets, lorries, dancers, fragments of old master paintings – floated in a soup of dripping paint. Rauschenberg's reaction to this triumph was to instruct his studio assistant in New York to destroy 150 of the silk-screens that had been used to make these pictures, so he would not repeat himself.

After I switched off the tape recorder I thanked him for talking to me. Rauschenberg replied, 'I felt you guessed all the answers before I gave them.' This was flattering but not really true. Naturally, when one prepares an interview, one tries to work out how it might go. But almost always, the interviewee quickly goes off that script and some of the things Rauschenberg had said were as unexpected as the turtle trying to clamber into the elevator.

Such surprises make interviews enlightening. I certainly learned from my encounter with Rauschenberg that day. In a way, it was a homecoming. Those silk-screen pictures that won the prize at the Venice Biennale had for some reason I can't quite fathom called to me when I was a teenager, so much so that at the age of 18 I had made some collages of my own in homage. They are still there, in a cardboard box in the attic: a possible path that in the end I did not follow. Now I regret I didn't tell Rauschenberg that. On the other hand, I know how he would have reacted: he would have said he didn't want people to make art like his, but to do something completely different.

19 Desperately Seeking Lorenzo Lotto

Some artists are easy to find; others you need to seek out. Many of Titian's paintings, for example, can be found in the great museums of the world – in London, Madrid, Vienna, Paris and New York – or in the churches at the centre of Venice. But with Titian's contemporary Lorenzo Lotto it is a different story. He led a wandering life, leaving masterpieces in small, sleepy by-ways. A good number of his most important pictures are scattered though the provincial towns of northern Italy. Of these, the largest – altarpieces particularly – are too big and fragile to travel to exhibitions. Therefore, you have to visit them, which requires time, patience – and luck. So finding one gives the kind of thrill a birdwatcher might feel on spotting a rare species.

Lotto has fascinated me since, half a lifetime ago, I once wrote an essay about his work. Over the years I've tracked his paintings in the foothills of the Alps, visited exhibitions, and now I planned to see a couple of dozen of his pictures in the Marche – a region that lies between the Adriatic and the Apennines, south of the Veneto. But my quest for Lotto in Loreto, the first destination on a touring holiday, went disastrously awry.

One October morning, Josephine and I had driven straight there from Ancona airport. Loreto is a pilgrimage town, a kind of Italian Lourdes, on a high hill rising above the Adriatic. The sick come here, wheelchair-bound, to pray at the Holy House in which Jesus was brought up. According to a pious legend, this was carried to Loreto in 1292 by a flight of angels.

Personally, I was struck by something equally miraculous about the town's picture gallery – at least among provincial Italian museums – namely that it was open on Mondays. And that was the day on which we were beginning our holiday. Therefore I worked out, after carefully checking and rechecking the opening times, that within a couple of hours of landing we could see no fewer than eight pictures by Lotto.

However, it was not to be. Having caught an early flight, we were standing in the Renaissance piazza at Loreto before lunchtime. We decided to look at the Basilica first, so – after I had once more checked that according to the notice on the door the gallery was indeed open – we saw the Holy House.

Everything seemed to be going well. After a quick *panino* we were ready to hit the Lottos. We climbed a grand Renaissance staircase, entered the museum, and paid a steep 8 euros each. Then, just as we were about to enter, the woman behind the desk fixed us with a look, and – with a touch of defiance – declared that all eight Lottos were currently on loan to an exhibition in Bergamo. It was a terrible moment. Bergamo was almost 300 miles away.

She quickly added that the collection was well worth seeing anyway, but this proved to be an exaggeration. There was, it was true, a fine altarpiece by Crivelli, but I was too upset to enjoy it properly. Glumly we inspected the gallery where the Lottos usually hung, noting the lighter patches on the plaster that each had left on the walls.

An appalling possibility occurred to me. What if all the paintings I had intended to see on this trip were also on loan to this exhibition in Bergamo? My mood slumped, and Josephine thoughtfully suggested a change of plan. We could detour about twenty miles south in search of another painting: a huge Lotto altarpiece in a little hill town called Monte San Giusto. This was enticing. From photographs it looked marvellous: a bustling Shakespearean drama of a picture. It was

Basilica della Santa Casa, Loreto

a crucifixion scene, with a possible self-portrait of the artist near the central cross. Part of the appeal of Lotto is his emotional intensity. His holy figures twist and writhe, as though blown by winds of doubt and piety. In a way, perhaps, they are all self-portraits.

In contrast to many of his contemporaries, of whom we know almost nothing except their works, Lotto left a few tantalizing clues to his personality: revealing asides in his account book and a will made a few years before he died in 1557. In the latter, he described himself as 'old, alone, without any stable domestic arrangements and very anxious of mind'.

Probably, he'd always been a bit like that: solitary, neurotic, eccentric. This *Crucifixion* sounded as if it had a tremendous charge of his turbulence and emotion. And since it was far too big to move I was confident, on reflection, that this at least would not be in the infuriating exhibition at Bergamo.

Predictably, the journey to Monte San Giusto turned out to be longer, slower and more winding than I predicted. Gradually we rose from the coastal plain, and as we did so my spirits climbed. I had wanted to see this altarpiece since, decades ago, Michael Hirst, an art historian at the Courtauld Institute, had told me how wonderful it was

– then added, enticingly, that no one ever went to see it, hidden away up in the hills.

Eventually we got there. And surprisingly quickly, we found the small church that contained the Lotto. It was shut. A friendly builder working on the house next door tried the door himself, then we both saw a notice pinned to it. This stated that the church was closed indefinitely because of the 'seismic events' of August and October 2016. The disappointment was even more intense this time. We'd only been in Italy a few hours, and already been thwarted from seeing nine Lottos. I considered cutting short our ten-day tour and flying back home.

The second of the earthquakes of 2016 had been less than a year before our visit, and I had not realized how badly the effects were felt in this part of the Marche. The epicentres were the other side of the Apennines – a long drive, but as the crow flies the distance over the mountains to Umbria is not great. As we walked around the town, it became obvious that although no buildings had actually collapsed, a number of ancient structures had been shored up with massive timber scaffolding. There seemed no prospect of seeing this Lotto; at least, not for years. By the time we finally arrived in Recanati, where we were to spend the night, I was convinced the whole Lotto quest was a fiasco.

<p style="text-align:center">*</p>

Nevertheless, our hotel proved very comfortable and the next morning was sunny. After breakfast, we strolled over to the museum and, two minutes after it opened, were standing in front of a masterpiece. These were ideal conditions for art viewing. We were feeling relaxed and rested, and in a gallery we had entirely to ourselves. In the museum at Recanati, there were several paintings by Lotto, two of which were memorably marvellous. I began to suspect these were much better than the ones we had missed in Loreto.

One of them was a multi-panel altarpiece from 1506–08, when the artist was in his early thirties. Like many of Lotto's early pictures, this looked somewhat like the works of Giovanni Bellini, patriarch of Venetian painters. But already a distinct personality was apparent: uneasy, emotionally intense, his figures prone to emphatic gestures.

Lorenzo Lotto, The Recanati Annuciation, *c.* 1534,
Museo Civico Villa Colloredo Mels, Recanati

The saints flanking the Madonna stirred restlessly, their chins bristling with unshaven stubble. With its gilded frame and six painted panels, the altarpiece rose almost to the ceiling. There is an odd but revealing phrase – 'in the flesh' – for seeing art in reality, not reproduction. With Lotto and other Venetian painters it's almost exact: to appreciate them properly you have to stand in front of them. Only then can you sense the carnal reality of the people they depict, the glistening of their skin, gleam in their eyes, the weight of their bodies, the texture of their clothes. These are physical experiences, because paint is a physical substance: a layer of organic and inorganic chemicals that reflects the light, and consequently changes every time the light alters. There is no substitute for being there.

Next to this altarpiece was a painting of the *Transfiguration* from 1510–11 that was almost bad, certainly a failure; and quite different in style. In the meantime, Lotto had gone to Rome hoping to work on one of the great commissions of the day: the decoration of Pope Julius II's apartments. In this he succeeded, briefly, before being elbowed out by a much more urbane artist: Raphael. This *Transfiguration* caught Lotto trying to mimic Raphael's heroic, classical manner; he had perhaps had a glimpse of Michelangelo's Sistine Ceiling, too. The result was awkward, ungainly, almost ugly.

Vastly better was his *Annunciation* in the next room from a quarter of a century later, by which time Lotto had digested the influence of Raphael, regained his balance, and become a wonderfully quirky individual. It is almost cinematic, taking you right into a 16th-century room, in among the participants in the sacred drama. Lotto provided, so to speak, the archangel's eye view on Mary, who looks straight out of the picture at the spectator. In fact, she seems to be praying to *you*.

At the same time, he presents *her* view of Gabriel, who kneels in the middle distance, gesturing theatrically with his right arm, like an Italian having an animated discussion in a bar. On the floor beside her, a cat leaps away. Art historians cannot decide whether it stands for sin or the devil, but the town council of Recanati is in no doubt. This little animal is the symbol of the town.

Inspired by our success, I asked the helpful staff at the museum desk about another Lotto, this one in a hill town named Cingoli, much

nearer the mountains – and the earthquake zone. They looked it up, and told us that after the disaster this altarpiece had been removed from the church that normally housed it. It was now in the town hall, where it could be seen, but only on Saturday afternoons. Since it was now Tuesday, that seemed to be that.

So, instead, we wandered through Recanati to look at the palazzo where Giacomo Leopardi, greatest of Italian romantic poets, had spent his gloomy childhood. The tourist office happened to be nearby, and – since information about Italian opening hours can be strangely mutable – we inquired again about the Lotto in Cingoli. After a couple of telephone calls, the staff established that if we went there and asked in person at the library, there was a chance that the staff would arrange to open up the room with the picture in it. We decided to risk it.

The road to Cingoli wound up and up. The town likes to call itself the 'Balcony of Le Marche' because of the view over the plain towards Ancona and – allegedly, on a fine day – right across the Adriatic to Croatia. It was obvious as soon as we stepped out of the car that we were now on the slopes of the Apennines. The air was cooler, with a touch of wood-smoke. Here there were even more of the older buildings supported by scaffolding, some with alarming cracks.

Naturally, we quickly became lost, completely unable to find even the street that contained the library. Unfortunately, the guidebook to the Marche had been mislaid, possibly in the aftermath of discovering that the church with the *Crucifixion* was irretrievably closed. With the guidebook had gone our only street map of Cingoli; there was no Internet access.

I hate being lost, so much so that quite often I dream of not being able to find my way. Along with two other nightmares, missing trains and planes, it happens in reality quite frequently: cruelly often when I am searching for a church or museum containing a rare work of art.

However, Cingoli was a small place and after a while we stumbled on the main square. We were just reading a notice on the entrance to the Palazzo Comunale, containing more information about access, when a helpful man came out and said he would collect the appropriate key and let us into the room where the *Madonna* was displayed. After a while he came back, smote his forehead, and explained that although

Lorenzo Lotto, *Madonna of the Rosary*, 1539,
Church of San Domenico, Cingoli

he now had the key to the door of the room, he had accidentally locked himself out of the town hall. Fate seemed determined to thwart us.

Again we waited; eventually another man came along explaining that he had arranged to reveal the altarpiece to a group of enterprising Americans who would shortly be arriving in a coach. He ushered us in, up the stairs, and there was Lotto's *Madonna of the Rosary* – nearly thirteen feet high, beautifully preserved, magnificent and very strange. Under the circumstances, actually seeing it seemed almost miraculous.

Its most extraordinary feature is not the Madonna and Child on their throne, it's what towers above them: a huge rose bush grows up through a wooden frame bearing fifteen small, round pictures within the larger picture. These represent the fifteen Joyful, Sorrowful and Glorious Mysteries, that is, the events in the lives of Christ and Mary on which the devout meditate while saying the rosary.

Much of the sacred action in this picture centres on the offering of gifts. The Madonna is in the act of handing the rosary to St Dominic, who kneels on the left (she was believed to have given him the first such string of beads – still frequently to be seen in the Marche – while he lay unconscious from self-mortification in 1208). Below the Madonna and Child and kneeling saints a baby angel launches a plume of rose petals like a motor-race victor spraying champagne; another *putto* points firmly to the painter's signature: an advertisement for himself.

The strange composition, with pictures within pictures dangling in the rose arbour, was probably forced on the painter by his devout, provincial patrons. But Lotto was a good fit with such people. The writer Pietro Aretino began a letter to him with the greeting, 'O Lotto, good as goodness itself and virtuous as virtue'. Aretino went on, rather crushingly, to explain that Lotto was outclassed in his profession – by Aretino's friend Titian – but not in his 'attention to religion'. The *Madonna of the Rosary* was too idiosyncratically nutty to have gone down well in a cosmopolitan metropolis such as Venice. And indeed, Lotto did little business there, which was why he had to be sought out in places such as Cingoli.

We felt so elated at this success that I recklessly proposed we go another twenty miles or so in the opposite direction to the place where

we were staying the night in order to take in Iesi, an old but industrialized city known rather ominously as the 'little Milan of the Marche'.

Arriving there, once more we got lost, and although there was a signal, Google Maps unaccountably sent us in the wrong direction through a dusty, ancient town centre. In the late afternoon this was almost deserted and none of the few inhabitants we met had ever heard of the local art museum. Eventually we located it, on an upper floor of a huge palazzo tucked away on a side street. And there, in another beautiful deserted gallery, were four more Lottos: majestic, brilliant and slightly mad.

We finally arrived at our hotel, which was far to the south, exhausted and frazzled, having navigated the labyrinthine one-way system of yet another medieval Italian town. No doubt there are more relaxing pastimes than chasing through the Italian countryside in pursuit of elusive altarpieces. But it had been a good day.

As I drifted off to sleep, I realized that this was a mission, which – fortunately – I would never entirely complete. Even if I managed to see that *Crucifixion*, and one or two other outstanding Lotto items, I would still not be finished. I'd need to come back and see them all again. A contemporary painter, Luc Tuymans, once said to me that it was a sign of a good painting that it could not be memorized. That's true, and explains why it always looks different when you see it again. So, on another day, and mood, they would all seem changed. You never quite get to the end of a picture, let alone the life's work of a painter such as Lotto.

The pursuit of art is a journey that never stops; the more you see, the more you want to see.

List of illustrations

Measurements are given in centimetres, followed
by inches, height before width, unless stated
otherwise

Mountains, 1449. Hanging scroll, ink on paper, 141 × 53.4 (55⅝ × 21⅛), Shanghai Museum. The Picture Art Collection/Alamy Stock Photo. **p. 134** Henri Cartier-Bresson, *Alpes de Haute-Provence, near Cereste, France*, 1999. Photograph © Henri Cartier-Bresson/Magnum Photos. **p. 137** Henri Cartier-Bresson, *Rome, Italy*, 1959. Photograph © Henri Cartier-Bresson/Magnum Photos. **p. 142** Installation photograph of the exhibition *Ellsworth Kelly: Prints and Paintings*, Los Angeles County Museum of Art, 22 January–22 April 2012. Photograph © Ellsworth Kelly © Museum Associates, Los Angeles County Museum of Art (LACMA). © 2019. Digital Image Museum Associates/LACMA/Art Resource NY/Scala, Florence. **p. 145** Ellsworth Kelly, *Briar*, 1961. Ink on paper, 57.2 × 72.4 (22⅝ × 28⅝). The Wadsworth Atheneum. Gift of Mr. Samuel J. Wagstaff, Jr. in memory of Elva McCormick, 1980. Image courtesy Wadsworth Atheneum Museum of Art. © Ellsworth Kelly Foundation. **p. 147** Ellsworth Kelly in his Hôtel de Bourgogne studio, Paris, 1950. Photograph courtesy Ellsworth Kelly Studio © Ellsworth Kelly Foundation. **p. 153** Portrait of Robert Frank by Allen Ginsberg, 1984. Photograph © Allen Ginsberg/CORBIS/Corbis via Getty Images. **p. 155** Robert Frank, *The Americans*, book cover. Steidl first edition 2008. Photograph © Steidl Publishers. **p. 160** Gerhard Richter in his Cologne Studio, 2017. Photograph Ute Grabowsky/Photothek via Getty Images. **p. 163** Gerhard Richter, *Ema (Nude on a Staircase)*, 1966. Oil on canvas, 200 × 130 (78¾ × 51¼). Museum Ludwig Cologne. © Gerhard Richter 2019 (0134). **p. 165** Cologne Cathedral, south transept window, based on a design by Gerhard Richter, 2007. Photograph Hohe Domkirche Cologne, Dombauhütte Cologne, Matz und Schenk. **p. 170** Robert Rauschenberg, *Canto XIV: Circle Seven, Round 3, The Violent Against God, Nature, and Art*, from the series Thirty-Four Illustrations for Dante's Inferno, 1958–60. Transfer drawing, watercolour, gouache, pencil and red chalk on paper, 36.7 × 29.2 (14⅜ × 11½). The Museum of Modern Art, New York. Given anonymously. Acc. n.: 346.1963.14. Digital image, The Museum of Modern Art, New York/Scala, Florence. © Robert Rauschenberg Foundation/VAGA at ARS, NY and DACS, London 2019. **p. 173** Robert Rauschenberg with *Satellite* (1955) and the first state of *Monogram* (1955–59; first state 1955–56), New York, c. 1955. © Robert Rauschenberg Foundation/VAGA at ARS, NY and DACS, London 2019. **p. 178** Basilica della Santa Casa, Loreto, Italy. Photograph age fotostock/Alamy Stock Photo. **p. 180** Lorenzo Lotto, *The Recanati Annunciation*, c. 1534. Oil on canvas, 166 × 114 (65 × 45). Museo Civico Villa Colloredo Mels, Recanati. **p. 183** Lorenzo Lotto, *Madonna of the Rosary*, 1539. Oil on canvas, 264 × 384 (104 × 151¼). Church of San Domenico, Cingoli

Acknowledgments

The list of debts I have incurred during the quarter of a century of talking, travelling and looking recorded here is a long one.

My thanks are due, firstly, to those at numerous institutions and galleries who made particular interviews and journeys possible: Calum Sutton, then of Tate Modern, with whom I went to Marfa, Texas; James Lingwood of Artangel who organized the Roni Horn project in Iceland; Hans-Ulrich Obrist of the Serpentine who made my encounter with Gerhard Richter possible; Bernard Jacobson who arranged my conversation with Robert Rauschenberg; Alexandra Bradley and Kathleen Soriano who organized the excursion to Anselm Kiefer's studio at Barjac; and Kate Burvill who set up my meeting with Henri Cartier-Bresson.

Susan Marling of Just Radio played a crucial part in the genesis of many of the episodes included here. Firstly, she encouraged me to turn both interviews and travels into two series of *The Essay* on BBC Radio 3. Then she gave invaluable help in nursing them into shape and coaching me in the art of reading to a listening audience. Sophy Thompson, Julia MacKenzie, Annalaura Palma and the team at Thames & Hudson have been instrumental and – as ever – made tremendously deft and skilful contributions during the process of metamorphosing these experiences into a book. I owe much to the editors who sent me on many of these missions – and often suggested them in the first place: Sarah Crompton, Nancy Durrant, Susannah Herbert, Tom Horan, Caspar Llewellyn Smith, David Lister, Thomas Marks, Anna Murphy, Sam Phillips, John Preston, Nigel Reynolds, Ben Secher, Sarah Spankie, Igor Toronyi-Lalic and Karen Wright.

My daughter, Cecily, offered some crucial guidance. Lastly, but most of all, I am grateful to my wife, Josephine, editor of first resort and my companion on a number of the expeditions, who was rightly described by the critic Gillian Reynolds, when the radio talks were broadcast, as 'patient and resourceful'.

Index